101

Glimpses of the

South Fork

101

Glimpses of the

South Fork

RICHARD PANCHYK

FOREWORD BY STEVE LEVY

Charleston　　London

THE
History
PRESS

Published by The History Press
Charleston, SC 29403
www.historypress.net

First published 2009

Manufactured in the United States

ISBN 978.1.59629.670.1

Library of Congress Cataloging-in-Publication Data

Panchyk, Richard.
101 glimpses of the South Fork / Richard Panchyk.
p. cm.
ISBN 978-1-59629-670-1
1. South Fork (N.Y. : Peninsula)--History--Pictorial works. 2. Long
Island (N.Y.)--History, Local--Pictorial works. 3. Suffolk County
(N.Y.)--History, Local--Pictorial works. 4. Historic buildings--New York
(State)--South Fork (Peninsula)--Pictorial works. 5. Historic buildings--
New York (State)--Long Island--Pictorial works. 6. Historic buildings--
New York (State)--Suffolk County--Pictorial works. 7. South Fork (N.Y.
: Peninsula)--Social life and customs--Pictorial works. 8. Long Island
(N.Y.)--Social life and customs--Pictorial works. 9. Suffolk County
(N.Y.)--Social life and customs--Pictorial works. I. Title. II. Title: One
hundred and one glimpses of South Fork.
F127.S9P29 2009
974.7'25--dc22
2009002884

Notice: The information in this book is true and complete to the best
of our knowledge. It is offered without guarantee on the part of the
author or The History Press. The author and The History Press
disclaim all liability in connection with the use of this book.

CONTENTS

FOREWORD

Long Island's South Fork is home to some of the most popular and iconic sites on the entire eastern seaboard. Whether it is the star-studded Hamptons or the historic Montauk Lighthouse, the South Fork is a definite draw for Long Island.

Of course, that's just skimming the surface of the allure of Suffolk County's easternmost region. The South Fork is also home to two of the nation's top ten beaches, sprawling open space and parkland and thriving downtown communities with friendly faces all around. Long Island's South Fork is a true treasure.

The Hamptons are glamorized on television as being a hot spot for actors and influential people to spend their summers, but the South Fork has much more to it than that. It is my hope that through this book you will get a view of the South Fork from the eyes of those who see it year-round and appreciate all that it has to offer.

Steve Levy
Suffolk County Executive

PREFACE

I have studied history, historic preservation and the changing face of various communities in New York City and on Long Island for twenty years now. I first touched on the topic of historic preservation in my undergraduate thesis at Adelphi University, and then again in my graduate work at the University of Massachusetts. I also discussed historic preservation in one of my earlier books, *Archaeology for Kids* (2002), but then not again until recently with *A History of Westbury, Long Island* (2007). It was that book that really excited the local historian in me. It made me realize how many communities on Long Island had roots going back to the seventeenth century. There was so much history, so many stories still to be told. That Westbury book quickly led to another local-oriented book, *Forgotten Tales of Long Island* (2008). That book relies upon old and often obscure stories and folklore, rather than images, to reveal glimpses of the past on Long Island.

When my editor at The History Press suggested *101 Glimpses of Long Island's North Shore* (2008), I was intrigued. The idea of an image-oriented pocket-sized local history

book appealed strongly to me, and even more importantly, the idea of communicating a story via old photographs was very intriguing. Over the past ten years, I have selected more than one thousand images for use in my various books, so I understand the power a historic image can possess to reveal the mysteries of the past. I was very pleased with how the North Shore book turned out, and when my editor suggested *101 Glimpses of the South Fork*, I was excited by the prospect.

I have always been fascinated with the past, as far back as I can remember. First of all, I am interested in the ways in which we celebrate and remember our heritage, preserving it for future generations to know and understand. Yet I am perhaps even more curious about the ways in which we often try to forget the past and obliterate any of its remaining traces. The struggle between preservation and progress is a mighty and ongoing one around the country, but especially in an area such as Long Island, where land values have become so high and the housing crunch has become so critical. It seems that our society is enamored of all things new, including technology and buildings. We sometimes look with disdain upon the old and traditional, wanting instead to get newer and better. One problem is that renovation and restoration can quickly become more costly and challenging than new construction. Thousands of historic Long Island structures await restoration, and some of these are seemingly destined for the wrecking ball. But the wrecking ball is a necessary evil, because without

any new construction, we would be completely stuck in the past, without the proper facilities and infrastructure to lead modern lives.

At the same time, it is critical that we recognize that "new" has its own share of problems and that the wholesale disposal of "old" is not beneficial. In many cases, the old saying "they don't make them like they used to" holds true. Old buildings are generally more solid and last longer than newer ones. In the days when people built their own homes or oversaw every detail of their construction, extra care was taken to make strong and lasting buildings. How often we read about this new building or that new structure that has a problem, was built wrong or was constructed with shoddy materials. Besides, a society cannot simply discard its past, if only because the past offers valuable lessons and helps us understand where we came from and can also offer warnings about where we are going.

Thanks to two New Deal–era programs begun in 1933 during the Great Depression, under the presidency of Franklin D. Roosevelt, a record of some of the historic structures of Suffolk County has been preserved. Under the Historic American Buildings Survey (HABS) and Historic American Engineering Record (HAER), thirty-five thousand structures around the country dating to the seventeenth, eighteenth and nineteenth centuries were thoroughly documented in photographs, drawings and captions. It is impossible to know how many of these structures remain intact, but it is certainly fair to say that a

great number of them have since been demolished, some within only a few years of their documentation. Luckily, on the South Fork of Long Island, many of the old historic structures do still exist, thanks to the appreciation these communities have for their storied pasts.

Acknowledgements

I want to extend a very special thank-you to the great Suffolk County Executive Steve Levy for taking the time to contribute a foreword. Thanks to Susan Kovarik of the Historical Society of the Westburys for her gracious assistance in offering the resources of one of Long Island's finest and oldest collections of local history. Thanks also to Katherine Powis of the Horticultural Society of New York for her assistance and kindness. Thanks to Jean Prommersberger for providing images. I also want to thank my editor at The History Press, Kate Pluhar, for working with me on this interesting project, and also thanks to the rest of The History Press family who has worked closely with me on my various projects. And thanks to Caren and the rest of my family for their continued support.

Photo Credits

Library of Congress, Prints and Photographs Division: Pages 36–37, 45–54, 56–57, 59, 61, 63–66, 70–73, 75–

87, 90 (top), 91–92, 99 (bottom), 109, 121, 125 (top), 126 (bottom)

Author's Collection: Pages 55, 60, 67–69, 95–96, 98, 101, 106, 110, 113, 115–16, 122, 123 (top), 124, 127

Historical Society of the Westburys Collection: Pages 35, 38–44, 58, 62, 89, 90 (bottom), 93–94, 97, 99 (top), 100, 102–03, 107–08, 112, 120, 123 (bottom)

Jean Prommersberger: Pages 119, 125 (bottom), 126 (top)

Horticultural Society of New York: Pages 104–05

United States Geological Survey: Page 111

ERDC Coastal and Hydraulics Laboratory: Pages 117–18

AUTHOR'S NOTE

This book is meant to provide glimpses of a bygone era, of the days when the Hamptons were crowded, but not *overcrowded*, the days before the Long Island Expressway and the Northern State Parkway extended their reaches far into Suffolk County. Naturally, huge volumes could be published to document the history of each of the various South Fork communities in photographs. In fact, many of these communities are already celebrated in their own historical and photographic compilations. However, the intent of this little book is not to provide comprehensive documentation of any one place in particular, but rather to give a sweeping view across the South Fork at various people, places and events from the late nineteenth to the mid-twentieth centuries.

The South Fork is rich in history, culture and natural beauty. I have carefully selected each of the images in the book and have tried to represent as many different communities and colorful local personalities as possible. I hope that you enjoy this little book.

INTRODUCTION

North versus South

Anyone who lives on Long Island understands that there is a clear distinction between North Fork and South Fork, just as there is between North Shore and South Shore in Nassau County. To the outsider, it may seem most curious that there could be such a sharp dichotomy between two places that are so close together and so narrow in width. Yet no one can deny that there is a very certain distinction. First, and most simply, is the obvious geographical difference; the North Fork leads to the Long Island Sound, with its views of Connecticut. On the other hand, the South Fork leads to the great expanse of the Atlantic Ocean, with its frothy waves licking at the beaches. In terms of size, the South Fork is longer and has more area than the North Fork, with many more villages.

Besides these clear physical and geographical differences, there are other, more social differences and distinctions. In fact, there is a very distinct sense of competition between the North and South Forks. The trendy and immensely popular South Fork has grown ever more crowded and expensive

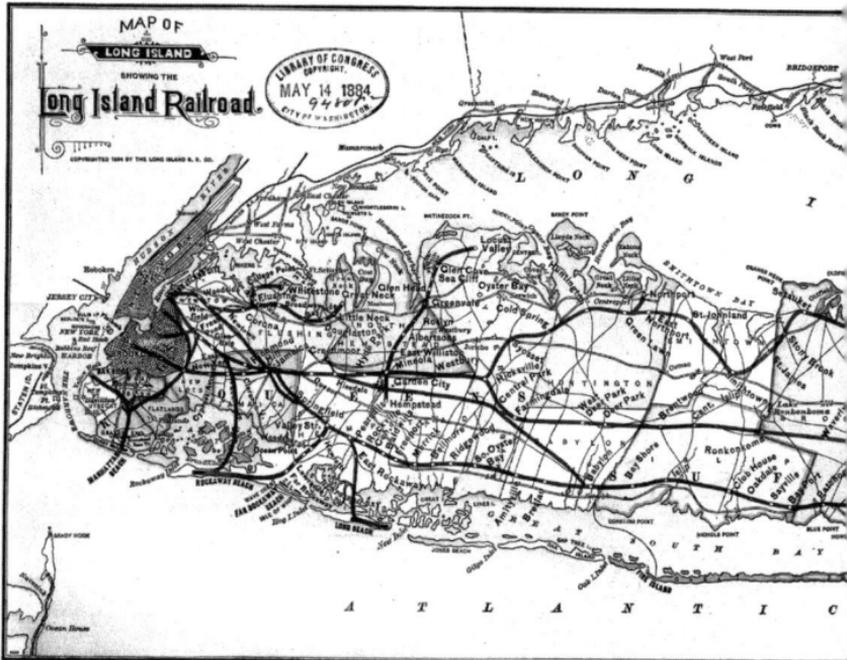

Long Island Railroad map showing the system as it was in 1884, when it extended as far as Sag Harbor. Other destinations on the South Fork had to be reached by stage.

in recent years than the quieter North Fork. Greenport, Jamesport, Southold and Orient have their share of summer homes, but the North Fork did not develop a "summer colony" to the extent of the South Fork. In some ways, the North Fork has come to represent the anti–South Fork, offering a quieter alternative for those seeking to vacation on

G3802.L6P3 1884 .L6 RR 448

the East End. These days, both the North and South Forks are popular destinations for those who crave an exciting, historical getaway complete with sun and sand.

A Thriving Place

We like to think that Long Island's South Fork communities were founded by the English back in the 1600s. But in fact,

Native Americans had settled the Twin Forks long before Verrazzano or Hudson sailed to the New York area in the sixteenth and seventeenth centuries. In fact, the first European settlers found that Native Americans were living throughout Long Island. Over time, countless thousands of natives were either assimilated or eradicated after the Europeans moved in. Thankfully, at least some local culture and history has been preserved because of the Shinnecock Reservation that was set aside in the nineteenth century.

The early European settlers on the South Fork lived off the bounty of the land and the sea. They lived in small settlements, passing a quiet, almost rural existence. These early settlers had closer ties to towns in Connecticut, from which they were a couple of boat rides away, than to New York City and Queens County. Their peaceful existence continued until the 1770s, when the British occupied Long Island during the American Revolution. Many adventures marked this occupation, including tales of Patriot spies, Tory revenge and raids and pilfering of food and valuables. However, within a few years of the Revolution's end, life was back to normal on the South Fork. The South Fork's population saw a moderate increase during the years 1790 to 1830; Southampton rose from 3,408 to 5,275 people in those years, and East Hampton rose from 1,497 to 1,819 people.

The South Fork's population was also relatively stable during the mid-nineteenth century. The population of the town of Southampton in 1840 was 6,205; in 1845 it was 7,212; in 1850 it was 6,501; in 1855 it was 6,821; in 1860 it

was 6,803; in 1865 it was 6,194; and in 1870 it was 6,135. Similarly, in East Hampton, the population increased only very gradually, from 2,076 in 1840 to 2,372 in 1870. These South Fork towns were by no means the most populous in Suffolk County. By comparison, in 1870, Brookhaven was home to 10,159 people, Huntington 10,704 people and Southold 6,715 people.

While Southampton, Sag Harbor and East Hampton were three of the larger South Fork settlements, there were numerous other smaller villages on the South Fork. By 1870, the South Fork was rich with tiny hamlets such as Atlanticville (population 179), Springville (eighteen houses), Red Creek (six houses), Squiretown (six houses), North Sea (population 112), Water Mill (thirty houses), Hay Ground (twenty houses), Scuttle Hole (twenty-five houses), the Springs (sixty houses) and Union Place (twenty houses). Though it was not as populous as other Suffolk locales, the South Fork was quite a thriving place.

Farming and especially the whaling and fishing industries had made places such as Southampton and Sag Harbor prosperous locales. In fact, whaling alone had a huge effect on the local economy. In 1807, there were only four whaling ships based out of Sag Harbor. By 1832, there were twenty; by 1841, there were forty-four; by 1845, there were sixty-one; and by 1847, there were sixty-three. In the year 1837 alone, 236,757 pounds of whalebone and 31,784 barrels of whale oil were brought back to Sag Harbor. At its peak, the whaling business employed eight hundred locals in various

aspects of the industry. From the 1780s through to 1837, 350,000 barrels of oil and 1,596,765 pounds of whalebone were brought to Sag Harbor. There was so much whale oil arriving that something in the neighborhood of 25,000 wooden barrels had to be manufactured each year in Sag Harbor to contain all that oil.

There were ample schools, churches, shops and other amenities for the local population to enjoy. It would not be long, however, before everything began to change. Soon after its peak, the whaling industry began a rapid decline. An 1870s travel guide wrote of Sag Harbor: "There is no reason why Sag Harbor should not, as a manufacturing village or summer resort, build up a future as bright as its past, and by a renewal of its early prosperity achieve a permanent success."

A Summer Colony

Up until the 1870s, a trip from New York City to the South Fork was long and arduous, accomplished via stagecoach. This is not to say that nobody from Queens or Manhattan ever visited, for there surely were visitors. However, the number of long-distance visitors was limited and well within the capacity of the existing hospitality within the South Fork communities.

The turning point in the South Fork's history was the coming of the railroad during the 1870s. With this monumental event, it suddenly became possible to journey

from Manhattan or Queens out to Southampton with some degree of speed, and also in relative comfort and ease. One no longer had to worry about bumpy roads or staying overnight somewhere along the way. Once rail stations were established in South Fork communities and the trip could be accomplished in a matter of a few hours, city folk began to visit by the hundreds, many for the first time (but certainly not the last time). Trains ran from Long Island City (there was no rail tunnel under the East River yet), and the fares were not cheap. In 1877, the price for a ticket to Westhampton was $1.90, to Quogue $1.95, to Southampton $2.30, to Water Mill $2.35, to Bridgehampton $2.40 and to Sag Harbor $2.50. Hotels began to crop up to accommodate these railroad visitors; the railroad fare alone cost more than one night's stay at the Halsey House in Atlanticville. One of the first hotels was actually built just before the railroad arrived—Howell House in Westhampton, constructed at the urging of a South Fork visitor, showman P.T. Barnum. This hotel could accommodate up to one hundred people. During the nineteenth century, boardinghouses were far more common than hotels, if only for the reason that it took several years for development to catch up with the growing popularity of the South Fork. In the late 1870s, Bridgehampton boasted thirty-six boardinghouses that could accommodate up to a total of four hundred people.

The favorable impression that the earliest summer visitors had of the South Fork inspired them to return and also to spread the word to their family, friends and neighbors.

They told of clear ocean waters, old homesteads and clean and fresh air. They returned to the Hamptons not just to visit, but soon enough began to purchase summer homes for their families. Thus was born the South Fork's famed "summer colony," already well established by the 1880s.

There were even some people who decided to leave their city lives altogether and move permanently to the South Fork. They established themselves on the South Fork and became important parts of their communities. The population of the Hamptons and other South Fork communities was now on the rise after years of moderate growth.

As the nineteenth century drew to a close, numerous hotels and clubs were opened. One of the earliest was the Meadow Club, organized in 1883. These new facilities catered to the ever-increasing numbers of visitors who came to enjoy the South Fork every summer. The wide-open spaces of the South Fork allowed the relatively new sport of golf to be successfully introduced on Long Island. In fact, the Shinnecock Hills Golf Club, completed in 1891, was one of the first golf clubs in the country (and the first with an eighteen-hole course and a clubhouse). Tennis was another popular South Fork sport; tennis championships were held at the Meadow Club. The *New York Times* now printed articles detailing which wealthy families had arrived in the Hamptons for the summer (or had decided not to come) and when and whom they were entertaining at their lavish estates. Real estate prices rose as demand for land increased. What was once cheap farmland was now sold for development at a good price. Large and

elaborate Victorian mansions with landscaped grounds were constructed next to old colonial homesteads. Longtime local residents, the people whose ancestry on the South Fork extended back six or seven generations, commingled with the fashionable newcomers. The large infusion of money that these wealthy summer (and year-round) residents brought to the South Fork enabled the construction of new infrastructure and improvements. New libraries and schools were constructed. More shops and amenities were added. Some of the nation's top architects, such as Grosvenor Atterbury and McKim, Mead and White, were called upon to design many of these new South Fork buildings. The South Fork rose to a national level of prominence as homes and gardens (and the people who owned them) were featured in magazines and newspaper articles.

With all the new construction and the large households to serve, there were also a great many support personnel who now needed to move to the South Fork. Countless carpenters, bricklayers, painters, masons, electricians, plumbers, gardeners, chauffeurs, maids, servants, nannies, cooks, stable hands and grooms were now employed full time either by one estate owner or for various clients. New homes were built not just for the wealthy, but also for those who came to the South Fork as new jobs were created. Some might have come with their employers from the city and only stayed the summer; others would have remained on the South Fork permanently to attend to the year-round needs of grounds and animals.

Famous Montauk

While to many the storied Hamptons *are* the South Fork, it is impossible to forget Montauk. This community, isolated until recently from the rest of the island by its distance and situation, was nonetheless well established as a place of national prominence.

The first honor was bestowed upon Montauk with the construction of the now famous lighthouse in the 1790s. But it was several events of the nineteenth century that helped cement Montauk's place in the national memory. For example, the famous ship *Amistad* landed near Montauk in 1839. The complex battle over the slaves on the ship set off a battle that would reach the United States Supreme Court (and would eventually be made into a hit Hollywood film).

Besides that famous ship, which managed to land at Montauk in one piece, there have been many others that have not been so lucky. Despite the Montauk Lighthouse, there have been numerous wrecks off Montauk Point. One of the most famous and tragic was the 1,455-ton *John Milton* in 1858, in which all thirty-three people onboard were killed when the ship was wrecked in a snowstorm five miles west of Montauk Point. That wreck was due in part to the weather and in part to confusion over the Montauk Light, which had recently switched its beam from steady to flashing.

Other wrecks occurring near Montauk have been the schooner *Triumph*, the whaling ship *Forrester*, the brig *Marcellus*, the bark *Algea*, the light boat *Nantucket*, the brig *Flying Cloud* and the steamer *Amsterdam*. In *Historic and Descriptive Sketches of Suffolk County* (1874), author Richard Bayles wrote: "Fearfully interesting indeed would be the story of destruction that has been wrought by the high carnival of ocean upon this wild forbidding shore. Fragments of wrecks, embedded in the sand, are scattered at short intervals along the beach, reminding us how the mad waves make play-things of the noblest works of man."

Montauk Point also gained national prominence during the Spanish-American War, when it was selected as the ideal spot for a camp to hold men returning from battle in Cuba. The purpose of their stay would be partly to quarantine them to prevent an outbreak of yellow fever among the general population; the other purpose would be to care for those who were sick until they were recovered. In August 1898, Camp Wikoff was created on about fifteen thousand acres of land in the space of a few short weeks. Tents were pitched and numerous facilities were erected, including a hospital, steam laundry and disinfecting facility. Nearly two million feet of lumber were used for storage buildings and tent floors. A fifty-foot-deep well was dug with a capacity of 300,000 gallons per day and a water filtration plant was erected at a cost of $7,000. About 100 nurses were brought in along with doctors, cooks and many other support staff. Four tank cars of spring water were brought in from

Jamaica each day, along with 1,000 oranges and lemons and 2,000 gallons of milk per day. President William McKinley visited on September 3, 1898, and was pleased with the camp. To ensure that the soldiers were properly fed, the government ordered extensive supplies, including 2,100 pounds of halibut, 5,000 cans of pickles, 48,000 pounds of lima beans, 21,000 pounds of butter, 10,000 pounds of prunes, 23,000 pounds of oatmeal, 400,000 pounds of ice and 636,000 eggs. Besides the government supplies, the Red Cross also pitched in, supplying 10,344 cans of soup, 2,536 pillowcases, 4,733 pairs of pajamas, 6,554 towels and 10,946 handkerchiefs. A total of 21,870 troops stayed at Camp Wikoff, with about half of those requiring some medical attention. The entire camp was abandoned by the middle of November 1898, less than three months after opening.

With the extension of the railroad to Montauk, the invention of the automobile and new and improved roads, Montauk Point became much more of a destination in the twentieth century than it had previously been during the nineteenth century, when only the most adventurous tourists would make the journey. The construction of the developer Carl Fisher's famous and spacious Montauk Manor, along with the opening of Hither Hills State Park with its many campsites (both events occurring during the 1920s), made Montauk a vacation destination on its own merits for the first time and no longer an interesting day trip diversion.

INTRODUCTION

Artists and Writers

Toward the end of the nineteenth century, another phenomenon began to occur on the South Fork. Besides the ordinary wealthy visitors who had begun to arrive *en masse*, a new breed of summer and permanent residents began to take root in the Hamptons. It started when an association of artists known as the Tile Club visited the Hamptons in 1878. Among its members were Edwin Austin Abbey, William Mackay Laffan, Walter Paris, Charles S. Reinhart, Earl Shinn and Edward Wimbridge. Once an article appeared in *Scribner's Monthly* about the Tile Club's adventures out east, numerous other artists and writers began to flock to the South Fork, hoping not only for some rest and relaxation, but also to be inspired by its quaint charms and natural beauty. As a few of these creative types arrived, they attracted others to come. Word of mouth spread rapidly, and the South Fork became a haven for all manner of creative folk. The establishment of an art museum by patron Samuel L. Parrish in the 1890s also helped create the artist-friendly atmosphere that drew artists from near and far to the South Fork.

Some of the early artists who enjoyed the Hamptons were Childe Hassam, William Merritt Chase and Thomas Moran and his wife Mary Nimmo Moran. These important American artists not only lived there, they also worked there, painting numerous scenes of life on the South Fork and further memorializing the South Fork's beauty on canvases

that would wind up in private collections and museums around the country.

Among the earliest writers frequenting the South Fork were Ring Lardner, Grantland Rice, Irvin S. Cobb, John Wheeler and Percy Hammond; all of them found homes in East Hampton. Walt Whitman wrote glowingly of Montauk in his *Leaves of Grass*, as have many other writers, some who lived on the South Fork, but others who only visited.

The South Fork artists and writers of the last decade of the nineteenth century and first two decades of the twentieth century were followed by a new generation during the 1940s, 1950s and beyond. Among the most famous modern artists summering (or permanently residing) on the South Fork were Jackson Pollock and Lee Krasner, Willem and Elaine de Kooning, Larry Rivers, Franz Kline and Robert Motherwell. Beyond them came a generation of 1960s pop artists including Jim Dine, Roy Lichtenstein, Andy Warhol and James Rosenquist. As for mid-century writers, John Steinbeck had a home in Sag Harbor and Edward Albee had a place in Montauk, among several other prominent poets and writers who lived or frequented the South Fork.

The South Fork Today

In many ways, the South Fork communities of Long Island have changed a great deal from one hundred years ago. The popularity of the South Fork did not reach its peak with the

mass invasion of artists and writers during the early and mid-twentieth century. As the last of the great 1940s–60s generation of modern artists passed away, new ones took their places. Though the actors and writers of the old days are long gone, the current crop of stars has continued the tradition. In fact, there is hardly a celebrity today who does not currently or has not at some point owned property on the South Fork, or at the very least spent time dating or visiting with a famous friend on the South Fork.

The effect this has had on property values is astounding. Real estate prices continued to escalate as the twentieth century drew to a close, and the desirability of having a house in the Hamptons skyrocketed. The $1 million home became the $10 million home, which became the $20 million home and so on, with no upper limit in sight. A glance through some of the recent real estate listings shows a six-bedroom house on 4 acres in Water Mill available for a mere $27.5 million; a beachfront house on 4 acres in Montauk for $35 million; a nine-bedroom waterfront house in Southampton on 11 acres for $80 million; and a four-bedroom house on 115 acres in Bridgehampton for $95 million. The yearly taxes alone on most of these properties would make a sizeable down payment on a house elsewhere on Long Island.

Though real estate prices have risen dramatically, one thing that has remained constant over the last hundred years is the varying seasonal population of the South Fork. While many people in recent years have chosen to

A page of 1940s advertisements for South Fork hotels from a brochure on Southampton. Hotels, boardinghouses, restaurants and clubs of all kinds flourished on the South Fork beginning in the late nineteenth century.

make the South Fork their permanent home, there are still thousands of part-time residents who spend only summers in the Hamptons. This increase in population during the summer months makes traffic on local roads difficult and causes year-round residents to grimace. Parties, special events and festivals abound during the summer months, as some residents offer their own homes as summer rentals and spend their summers elsewhere.

The pressure of increasing population, high prices and unchecked commercial development has threatened to forever alter the South Fork of Long Island. In every historic community, there comes a tipping point, a time after which too much of the old has been lost and too much of the new has been carelessly planted in its place.

Luckily, the South Fork has not yet reached this tipping point. Despite the considerable changes that have come to the South Fork, there are also many things that have not seemed to change over the course of time. Despite the celebrity madness and the summer craziness, the South Fork communities retain their sense of place and history. Despite the development, a surprising number of large parcels of land still exist; granted, these are part of large estates. While the farming community of the South Fork is largely gone (it has survived to a greater degree on the North Fork), open spaces are still plentiful. Whaling is long gone, but vestiges and reminders of the whaling life still exist. Many of the old seventeenth- and eighteenth-century structures still stand and coexist with newer structures. Some stretches

of quiet country road still look much as they did in 1900. There are still old homes and barns, stately churches and numerous waterfront vistas. There is more than enough left to keep the South Fork a very special place. While the bucolic South Fork of the mid-nineteenth century is long gone, today's South Fork possesses more reminders of the unique charms of yore than many other parts of Long Island. The South Fork also has its windmills—very special and unique vestiges of its past that few places in the United States have.

As long as we continue to celebrate the South Fork's rich heritage, we will ensure that we never destroy it. Some of the places you will see in this book are long gone, but a surprising number still exist today. Their tenacity is a combination of luck, hard work and respect for the past.

LOCAL RESIDENTS

The Reverend Samuel Buell was born in Connecticut and came to East Hampton in 1746, where he served as the pastor of the Presbyterian church for many years, publishing fourteen of his best sermons. He received the degree of doctor of divinity from Dartmouth College in 1791. He also served as the first headmaster of the Clinton Academy, an institution that he helped found in the 1780s. He died in East Hampton in 1798. This image shows Buell as he looked toward the end of his life.

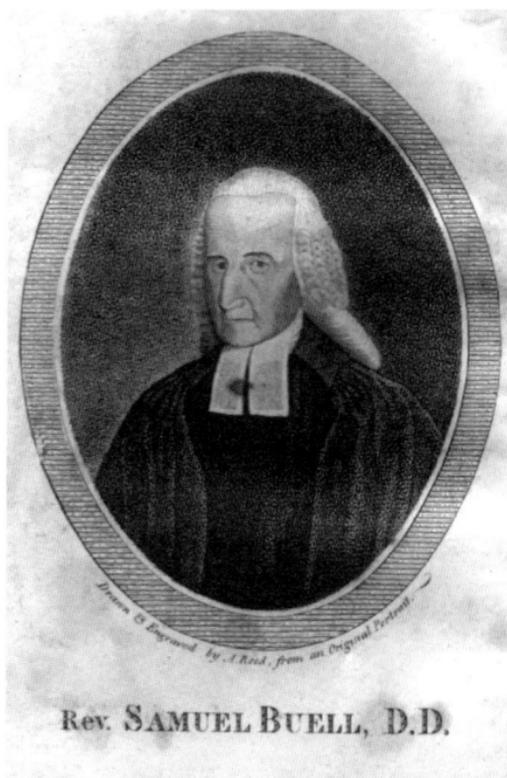

Rev. SAMUEL BUELL, D.D.

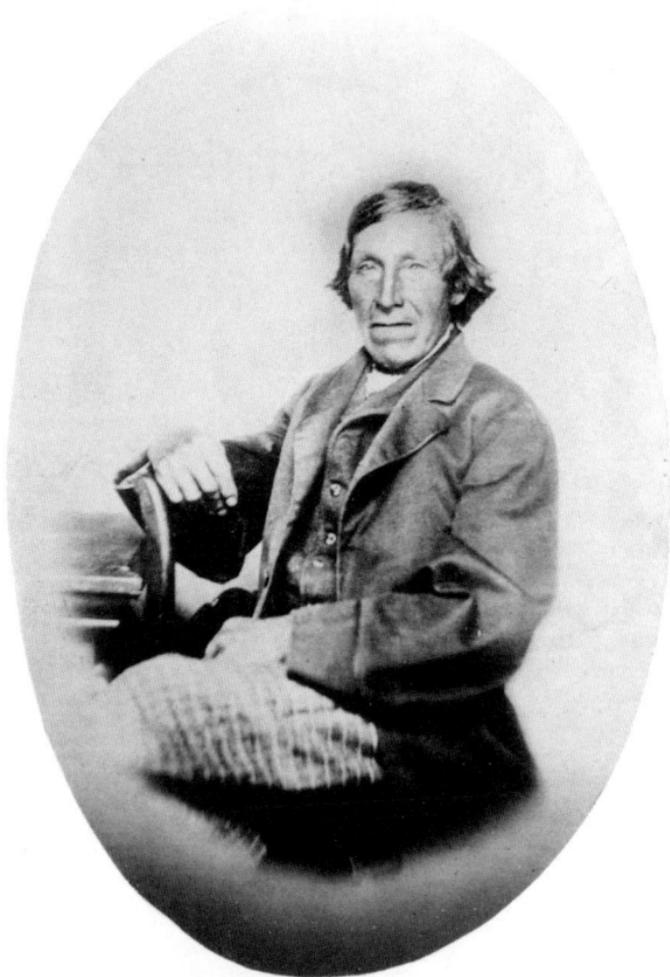

The Montauk Indians were formally known as the Montauket tribe. Their numbers dwindled with the arrival of Europeans on the South Fork. In 1660, there were five hundred left. By 1829, there were only thirty members of the tribe left, and by 1869 only six. This image shows a Montauk man photographed by Antonio Zeno Shindler, a noted photographer of American Indians, in 1868. David Pharaoh, the noted "Last King of the Montauk," died in the 1870s.

Local Residents

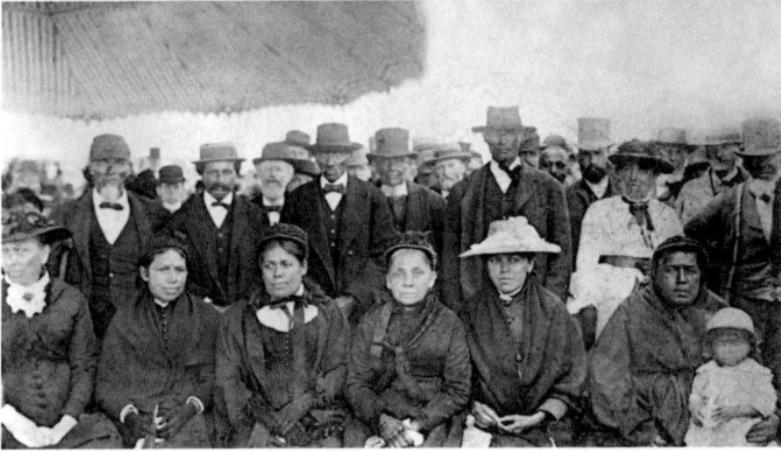

Taken in June 1884, this photograph was labeled "The Last of the Shinnecock Indians, L.I.," but that report of their demise was premature. Today, the Shinnecock Nation numbers more than 1,300 people, about half of whom live on a 1,200-acre reservation (created in 1859) at Shinnecock Neck on the South Fork.

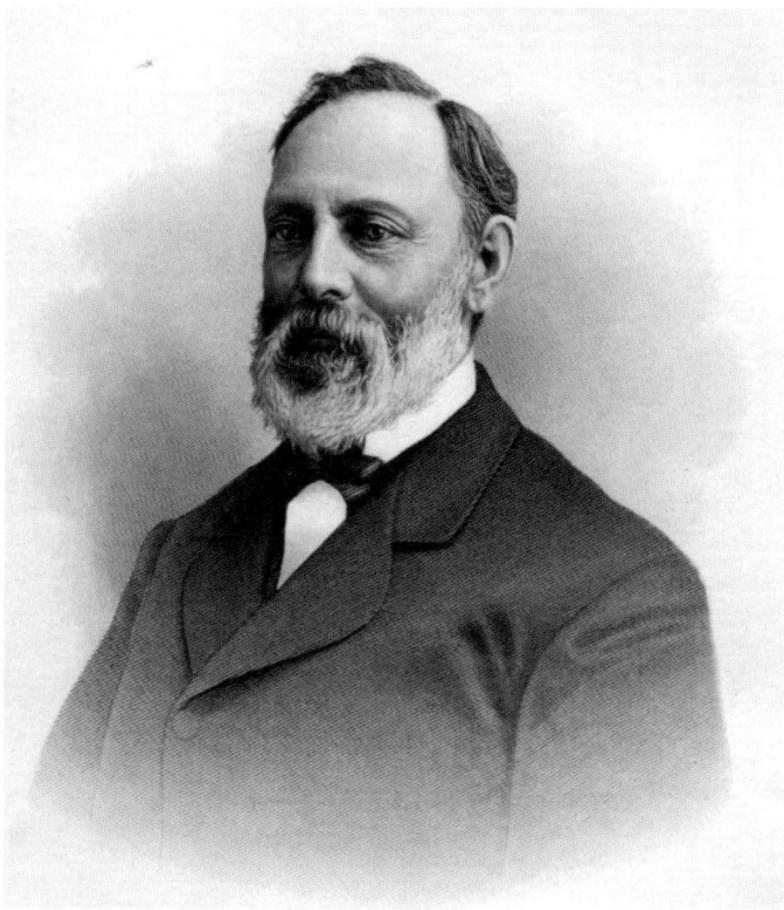

Noted attorney and judge Henry P. Hedges (1817–1911) was born in East Hampton. One of the founders of the Republican Party in 1856, in 1861 he became district attorney of Suffolk County, and county judge in 1865. From 1874 to 1880 he served as surrogate judge of Suffolk County. He was the author of *A History of the Town of East Hampton* in 1897, and in 1899, he gave an address at the celebration of the 250th anniversary of East Hampton's founding.

Local Residents

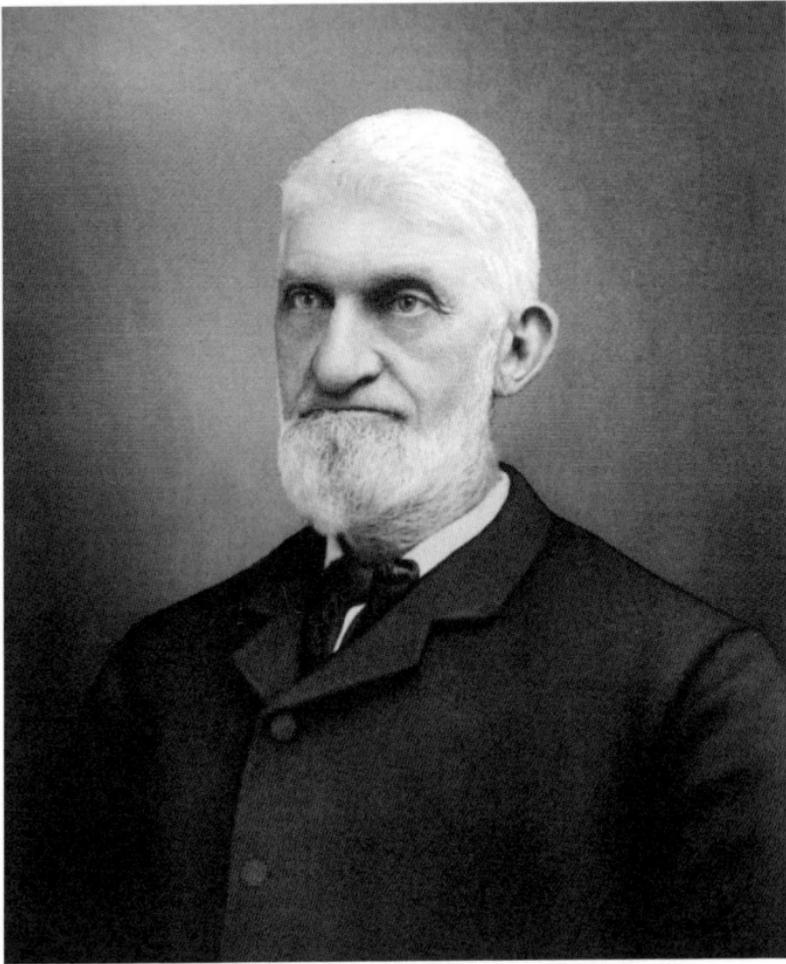

Captain George G. White (1819–1893) was a well-known whaling captain who was elected president of the board of town trustees of Southampton. During a storm in 1874, he courageously steered a lifeboat toward the wrecked steamer *Alexander Lavalley* and was able to rescue all of the crew.

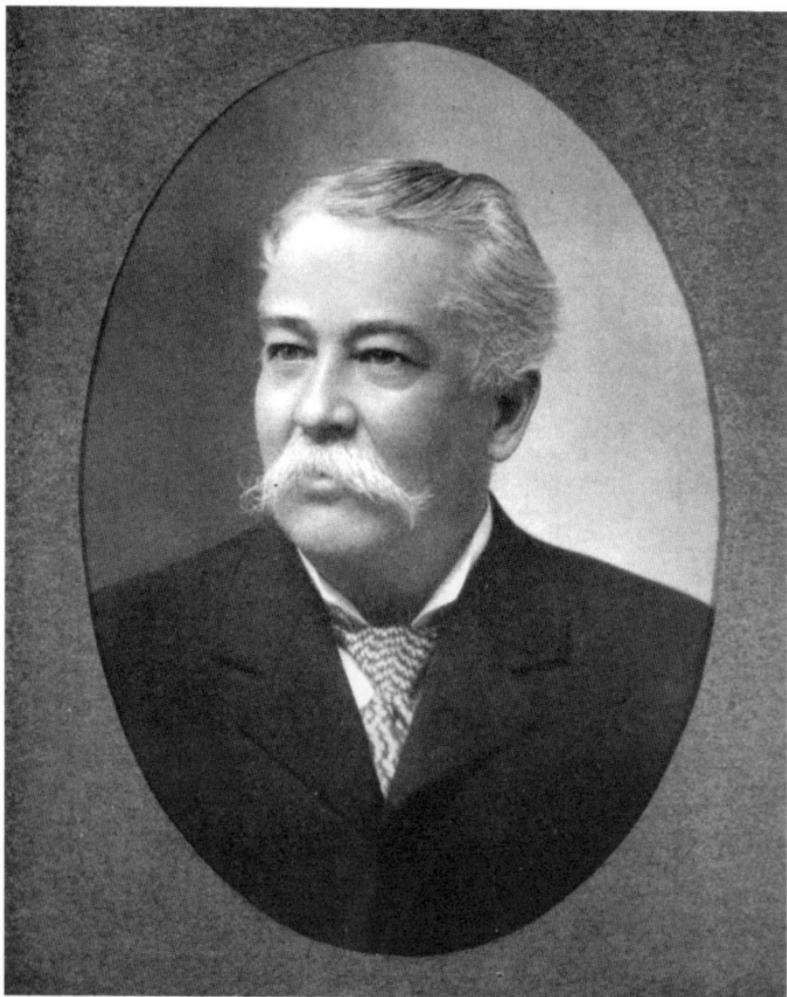

William Wallace Tooker (1848–1917) was born in Sag Harbor. He was an enthusiastic historian and antiquarian, student of archaeology and anthropology and had a fifteen-thousand-specimen collection of a wide variety of artifacts. One of his projects was researching hundreds of Indian place names on Long Island. He was the author of dozens of articles and essays on local history.

Local Residents

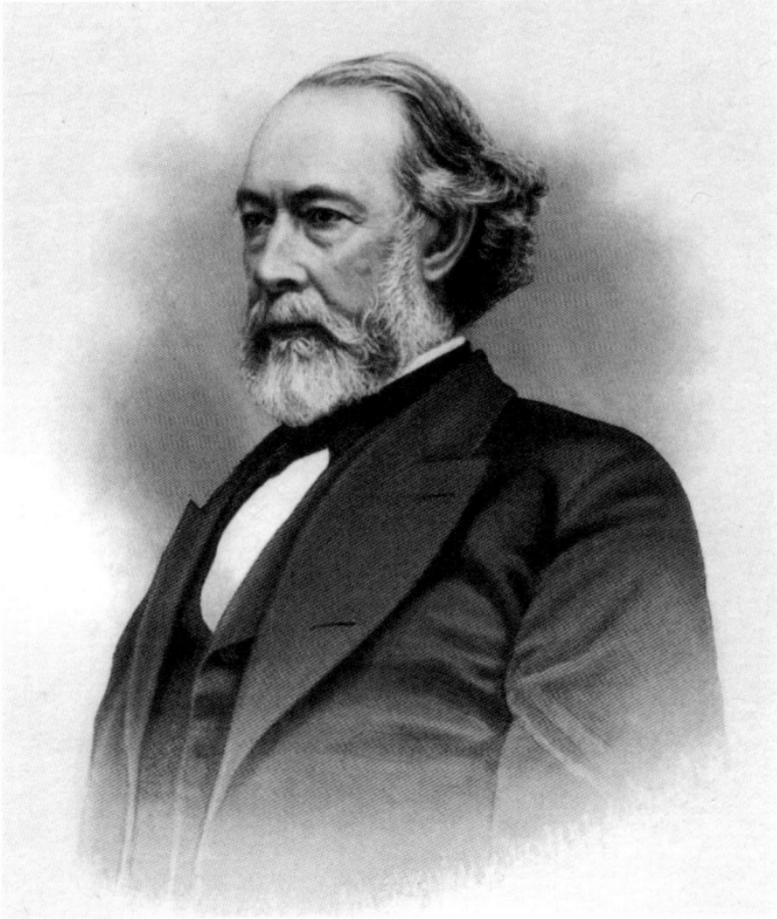

Samuel Buel Gardiner (1815–1882) was the tenth proprietor of Gardiners Island. He was elected to the state assembly in 1846. At the time of his death, Gardiners Island was assessed at a value of $60,000.

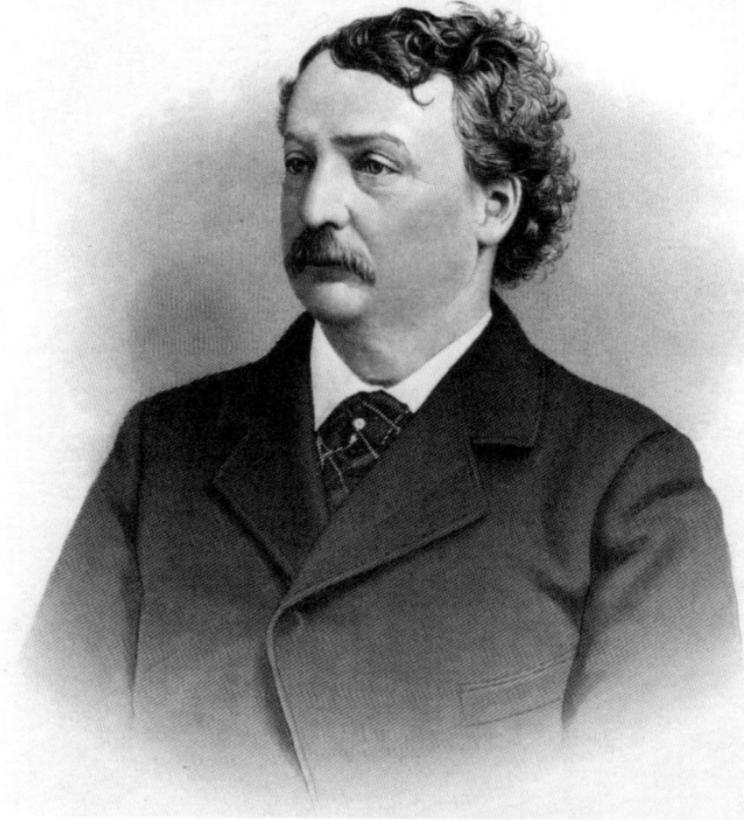

Everett A. Carpenter (born 1835) was a teacher and attorney. In early life, he was a delegate to the first Republican convention in Massachusetts. Later a resident of Sag Harbor, he was elected to the state assembly in 1879. He also served as U.S. assessor for Suffolk County and chairman of the Republican County Committee of Suffolk for eight years.

Local Residents

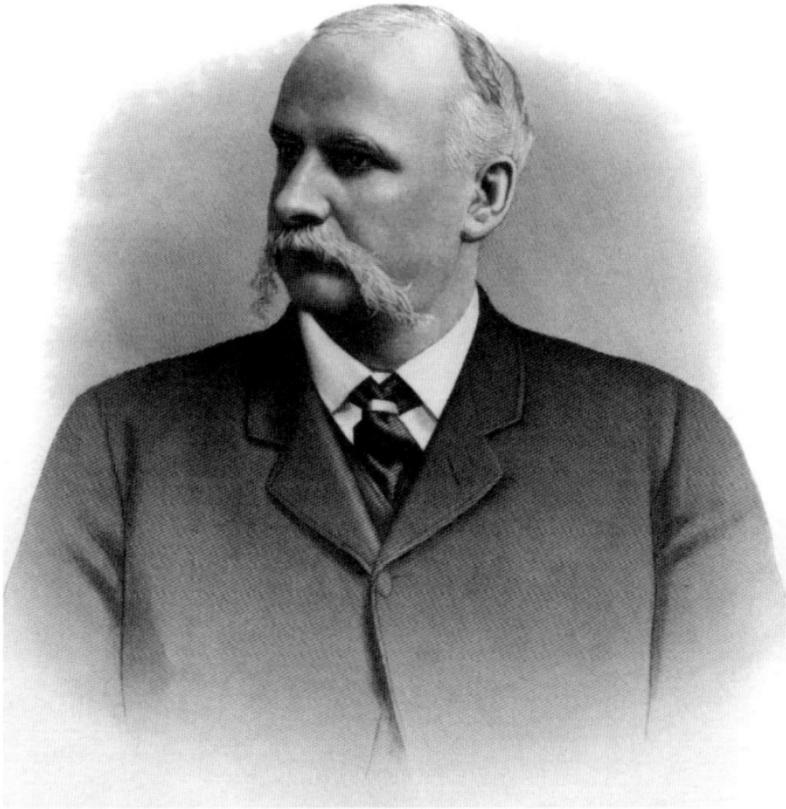

Stephen B. French (born 1829) was born in Riverhead but moved to Sag Harbor at the age of two. His early adventures included whaling and gold hunting. In 1868, he was elected treasurer of Suffolk County. He ran for Congress in 1874, but lost. In 1876, President Ulysses Grant appointed him appraiser at the Port of New York. In 1879, he was appointed as New York City's police commissioner.

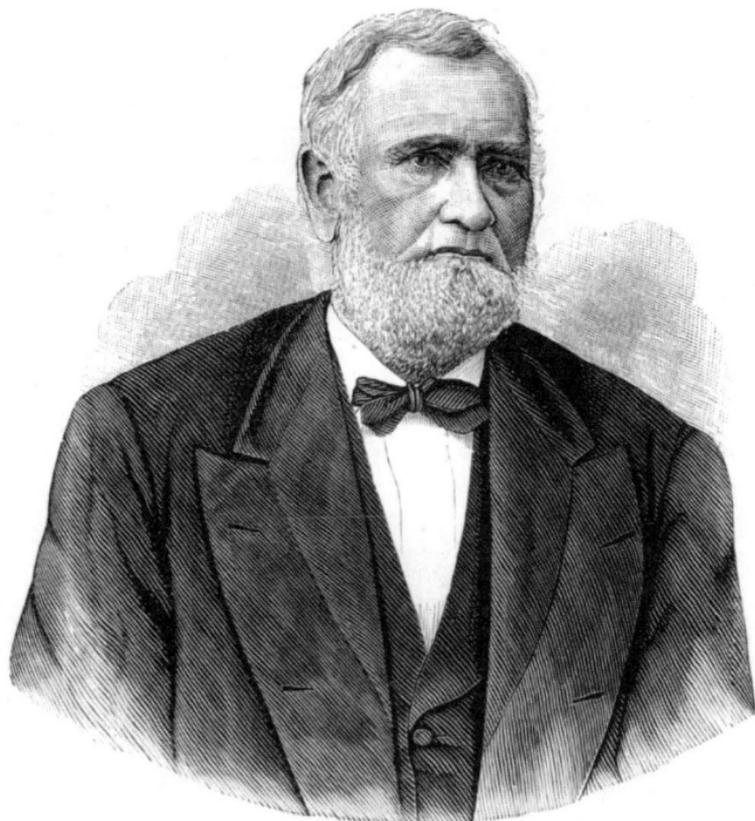

Captain James R. Huntting (1825–1882) was a successful whaling captain. He was born in Southampton and died in Bridgehampton. He was active in the whaling industry from the 1840s through the 1860s. He lived for some time in the Greek Revival Nathaniel Rogers House (also known as the Hampton House).

Local Residents

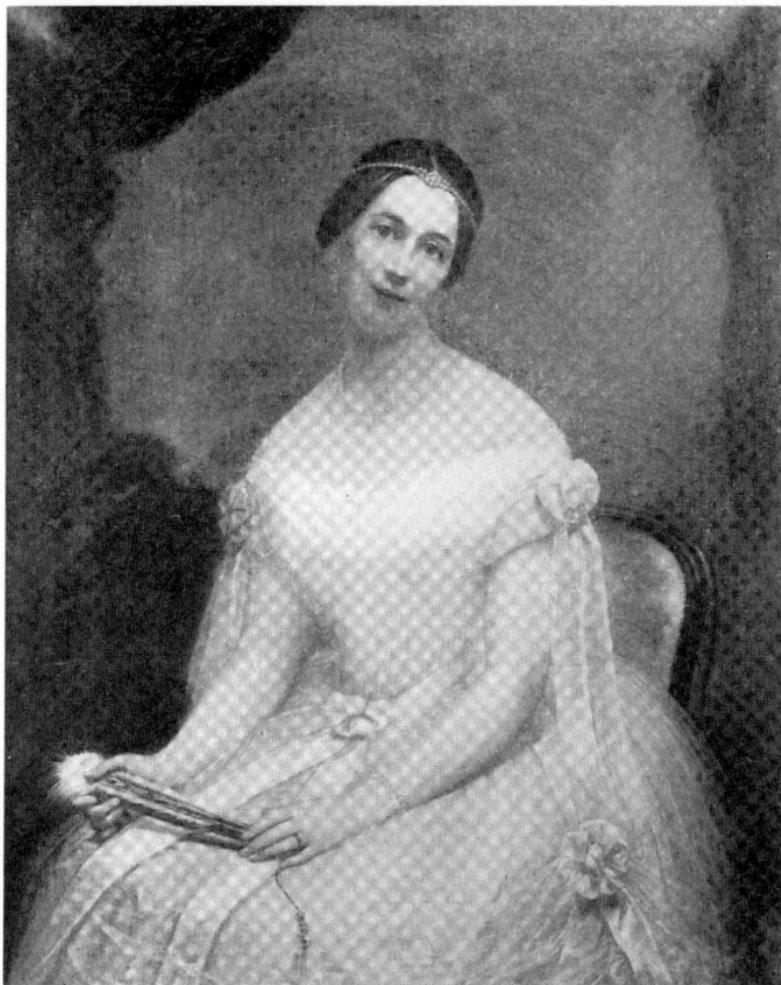

Julia Gardiner (1820–1889) was born on Gardiners Island, the daughter of New York State senator David Gardiner. She was famous in local society as the "Rose of Long Island" and married the widower President John Tyler in 1844 on Gardiners Island. She was first lady for a little over eight months.

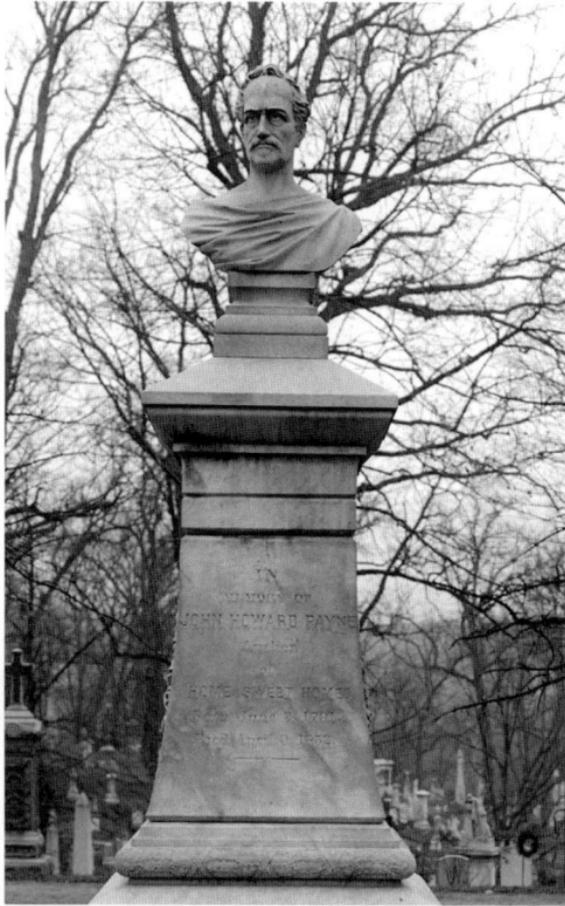

John Howard Payne (1791–1852) was an actor, writer and statesman. Born in New York City, he moved to East Hampton as a child. His life's travels took him many places, but he remains associated with East Hampton due to "Home Sweet Home," a song he wrote that was inspired by his childhood. Payne served as the American consul at Tunis, Tunisia, and died there. His remains were brought back to the Oak Hill cemetery in Washington, D.C., in 1883, where his bust rests atop his monument.

Chapter 2

WINDMILLS AND HISTORIC STRUCTURES

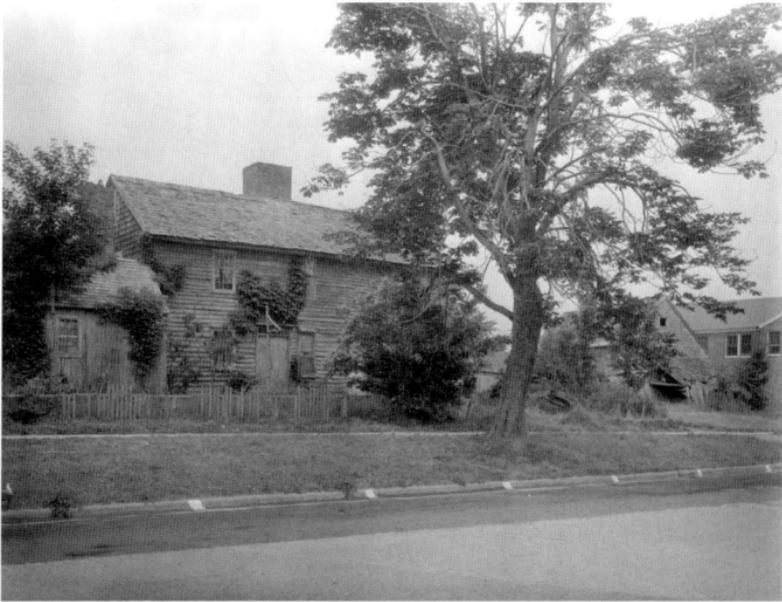

Dominy House was built circa 1715 and named after the family that owned it for three generations, beginning later that century. The American Impressionist and local resident Childe Hassam painted a picture of the house in 1928. It was demolished in 1946.

The Tuttle Fordham Mill was built in 1859 at Mill Road and Montauk Highway in Speonk, next to the original wooden sawmill. This water-powered mill was built by Daniel Tuttle for his carriage manufacturing business and bought by Everett Fordham in 1900. The twenty-five-by sixty-two-foot building was used for boring, drilling and turning lumber and was powered by water until about 1911. The building was eventually turned into an antique shop.

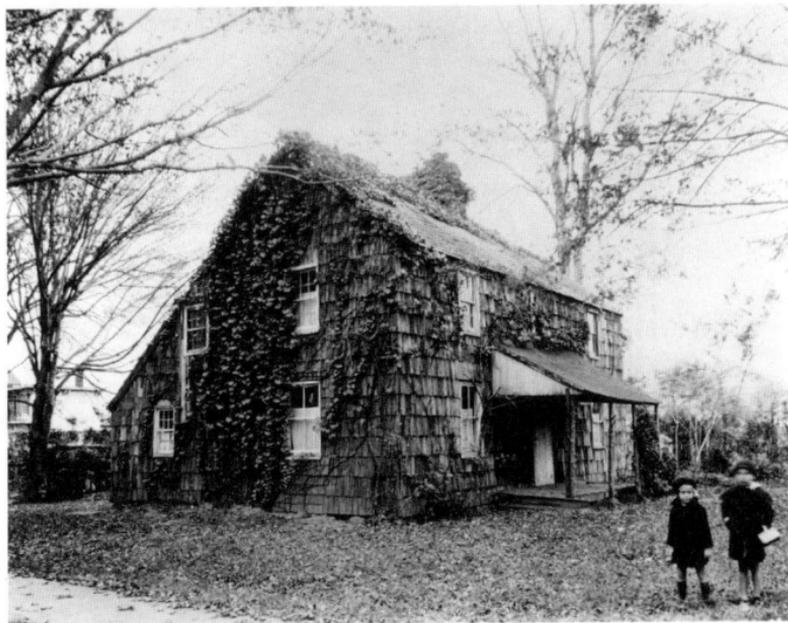

The Ananias Conklin House (aka the Cartwright House) was built circa 1700 on Main Street in Amagansett. This photograph of the structure was taken about 1940, not long before the building burned down. The Conklins were an early family in the area.

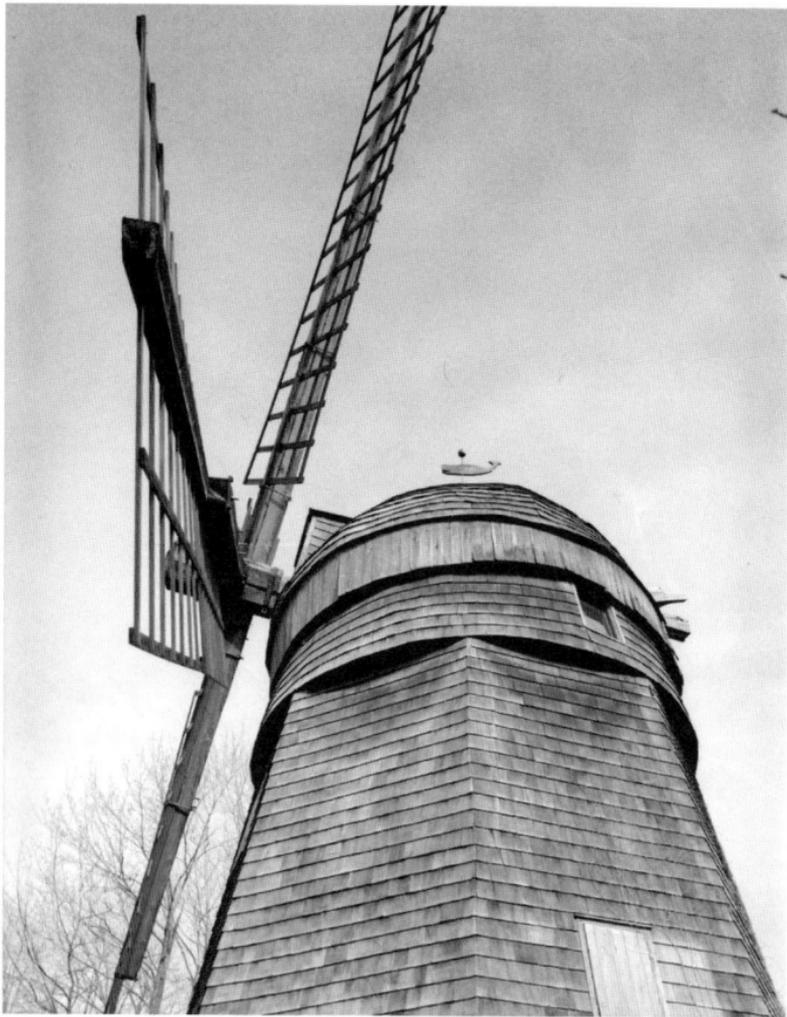

Samuel Schellinger built the Beebe Windmill in 1820 for Captain Lester Beebe at Sag Harbor. The mill was moved to Bridgehampton in 1837, to East Hampton in 1882 and finally to Southampton in 1915.

Windmills and Historic Structures

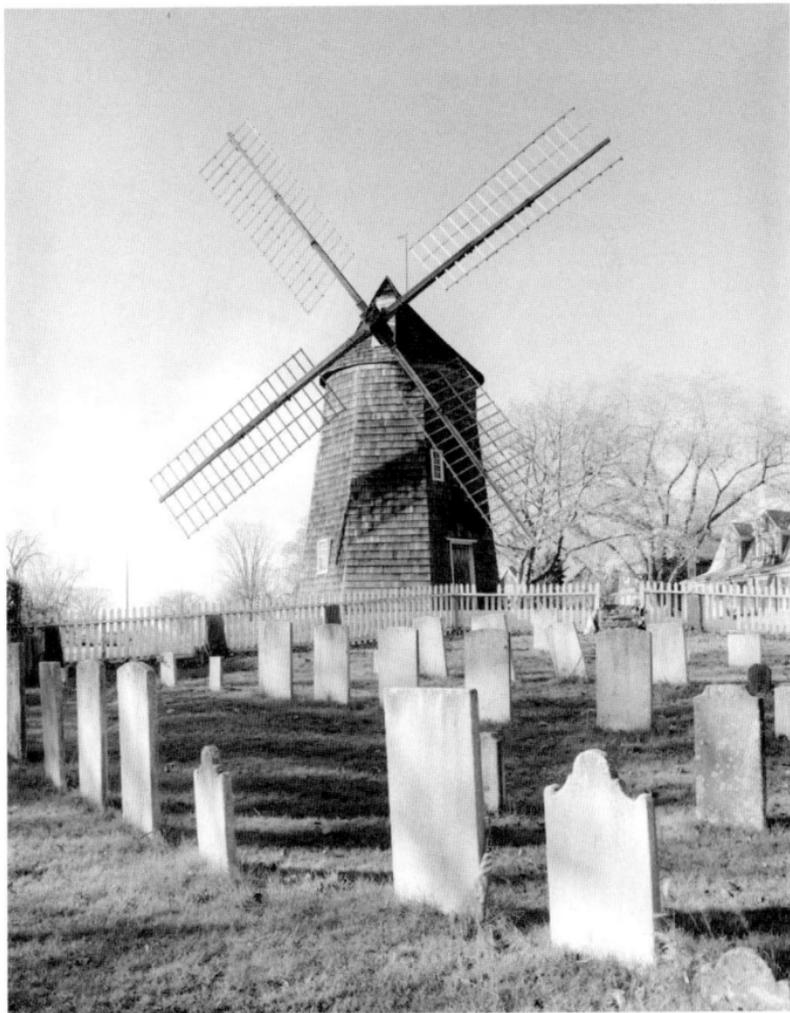

The Hook Windmill was built circa 1806 by the well-known East Hampton craftsman Nathaniel Dominy V (1770–1852). It was sold to the village of East Hampton in 1922 and restored by Charles Dominy (great-grandson of the original builder) in 1939.

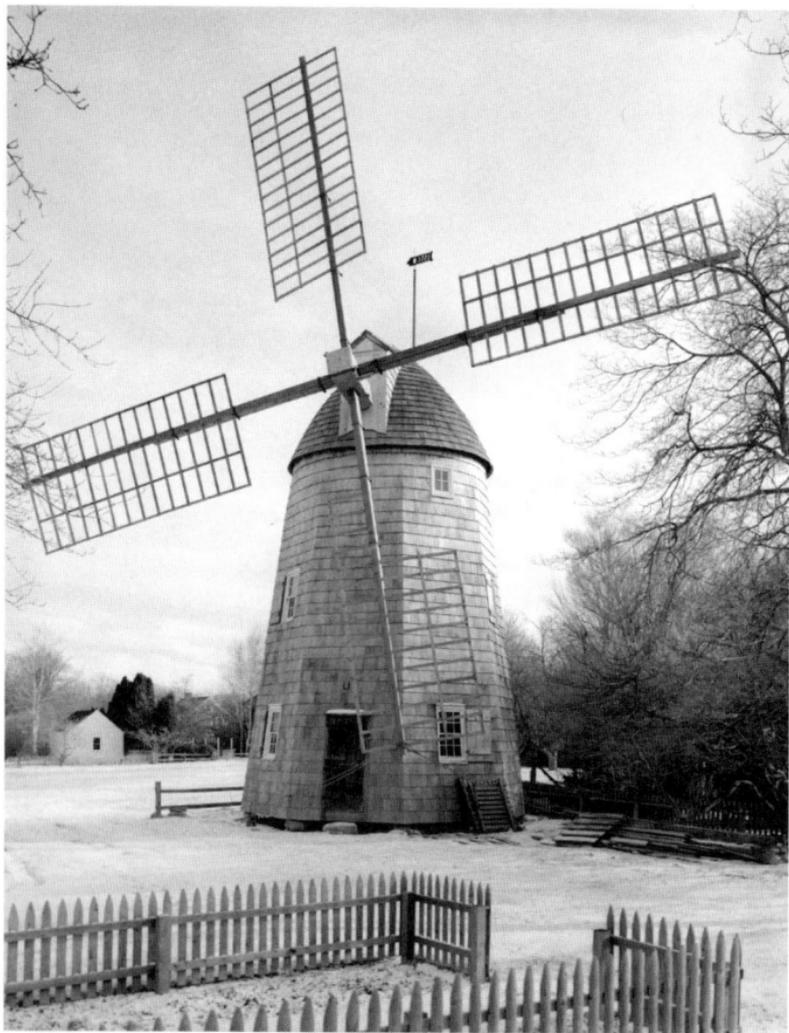

The Pantigo Windmill was built in 1804 in East Hampton by Samuel Schellinger for Huntting Miller. It was later moved to Pantigo Road (from whence it got its name) and Egypt Lane about a half mile from the village and remained there until 1917, when it was bought by Gustav Buek (who also owned Home Sweet Home). Buek moved it to his property on James Lane in East Hampton. The village eventually acquired the windmill.

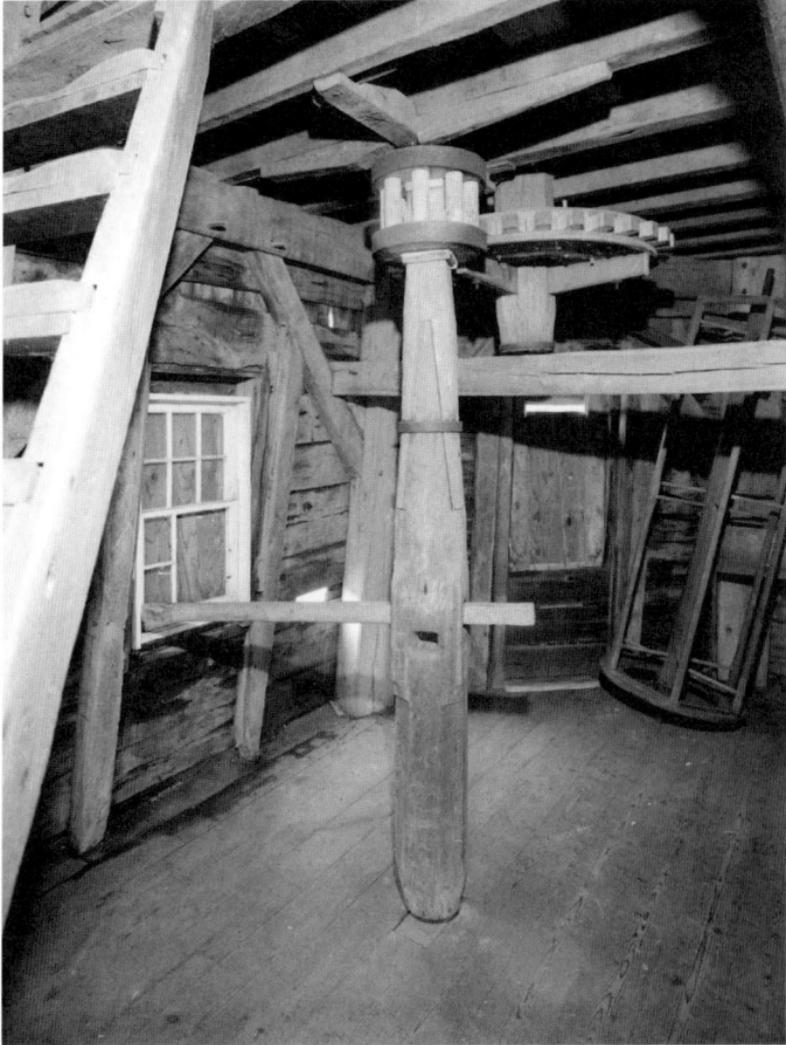

The Shelter Island windmill was built in 1810 by the well-known carpenter Nathaniel Dominy V of East Hampton. Originally located in Southold, the mill was moved to Shelter Island in 1840 and then moved again to a different location on the island in 1926. This image shows the inner workings of the mill.

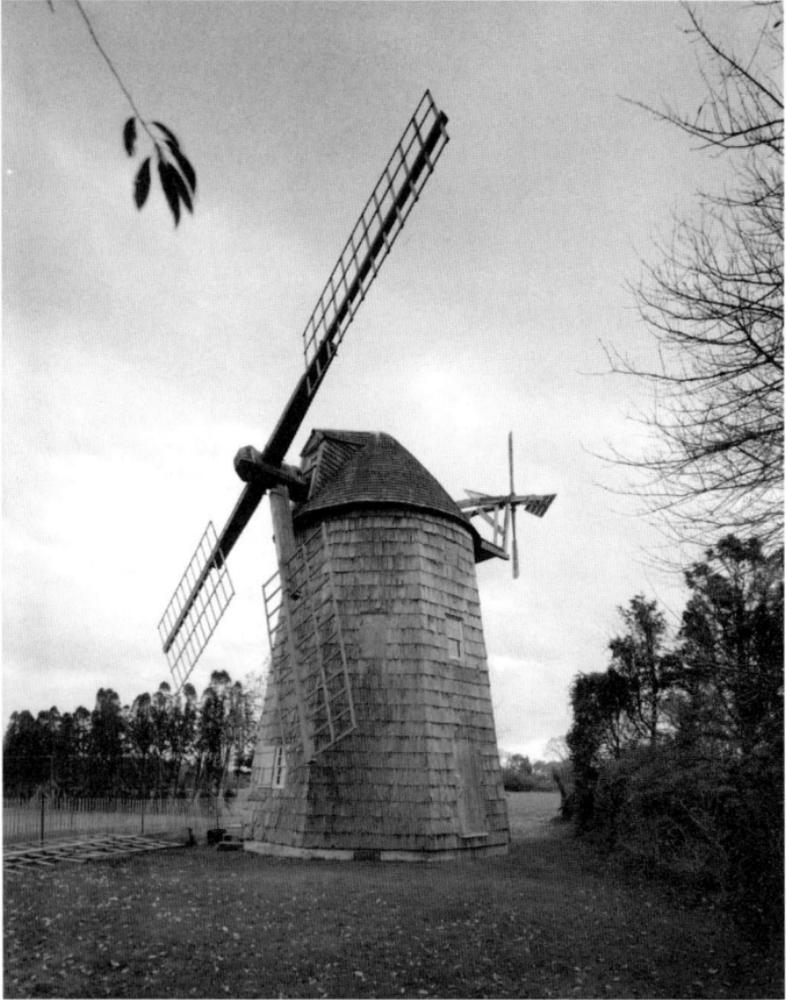

The Wainscott Windmill was built in Southampton in 1813 to replace a mill that had burned down. The original owners were Jeremiah Jagger and Joshua Sayre. The mill was sold several times and moved to Wainscott during the 1850s. It served as a public library during the early 1900s. In 1922, Lathrop Brown bought it and had it moved to Montauk. He gave the mill to the Georgica Association in the 1940s, which had it moved back to Wainscott.

Windmills and Historic Structures

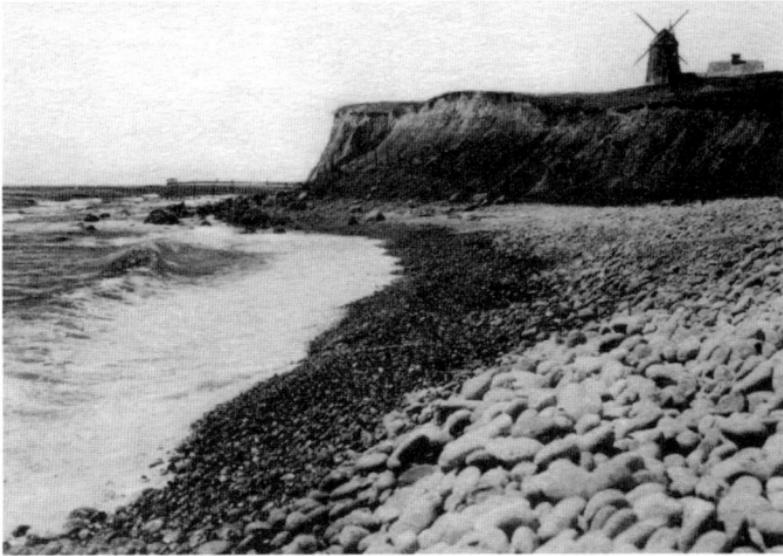

The Montauk Mill (located just west of the lighthouse) is shown here sometime between 1922, when former congressman Lathrop Brown had it moved from Wainscott, and 1942, when he donated it to the Georgica Association, which had it moved back to Wainscott.

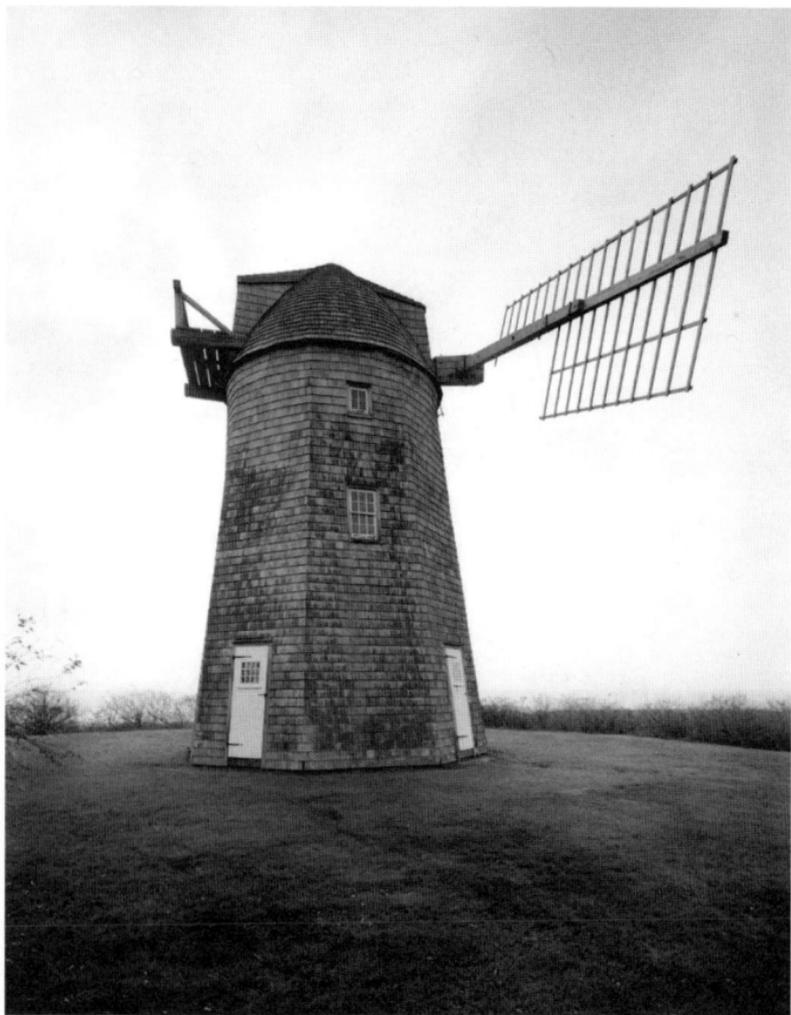

The Hayground Windmill was built in the village of Hayground circa 1801, and by 1919 it was the last operating mill on Long Island. It was used as an artist's studio after 1919 and then was bought by Robert Dowling in 1950 and moved to East Hampton.

Windmills and Historic Structures

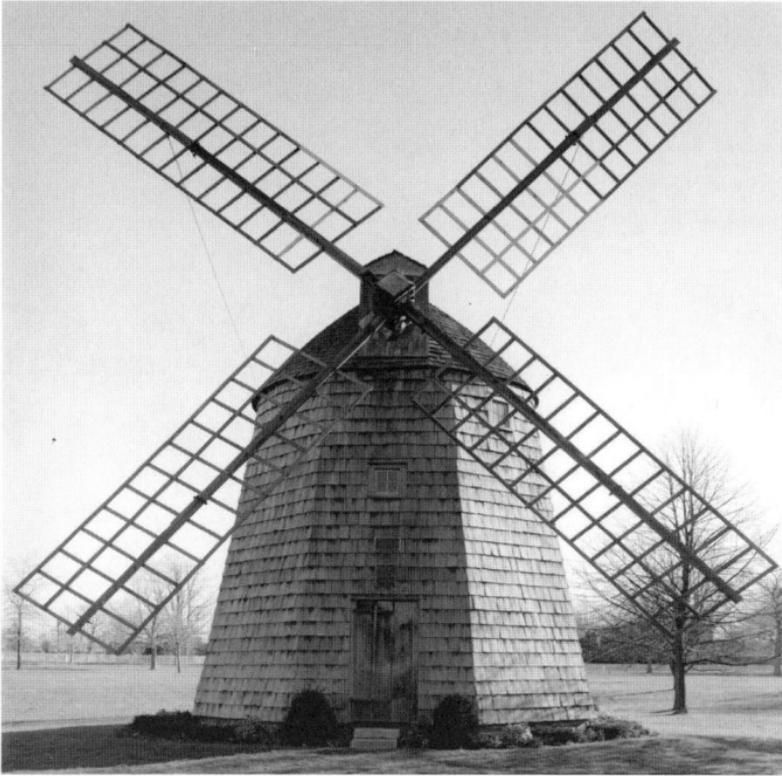

The Water Mill Windmill was built around 1800 in North Haven. Circa 1814, it was moved to Water Mill to replace a mill that had been lost in a storm. It ceased milling operations in 1887 and suffered neglect during the early twentieth century, but it was restored circa 1932 and again after it was damaged by the Hurricane of 1938.

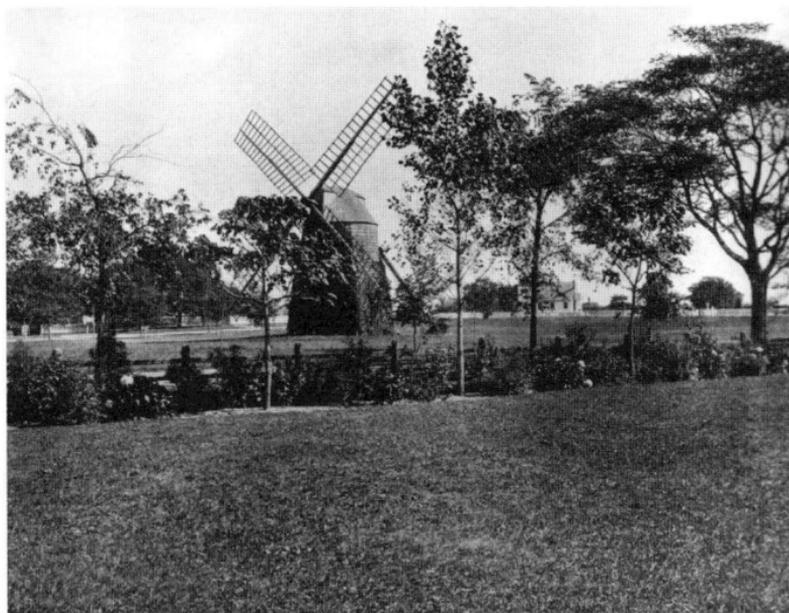

The Water Mill Windmill, the last remaining windmill at Water Mill, was purchased by Dr. E.L. Keyes in the 1890s, a few years after it had ceased milling operations and just as it was about to be demolished. His intent was to preserve it as a landmark.

Windmills and Historic Structures

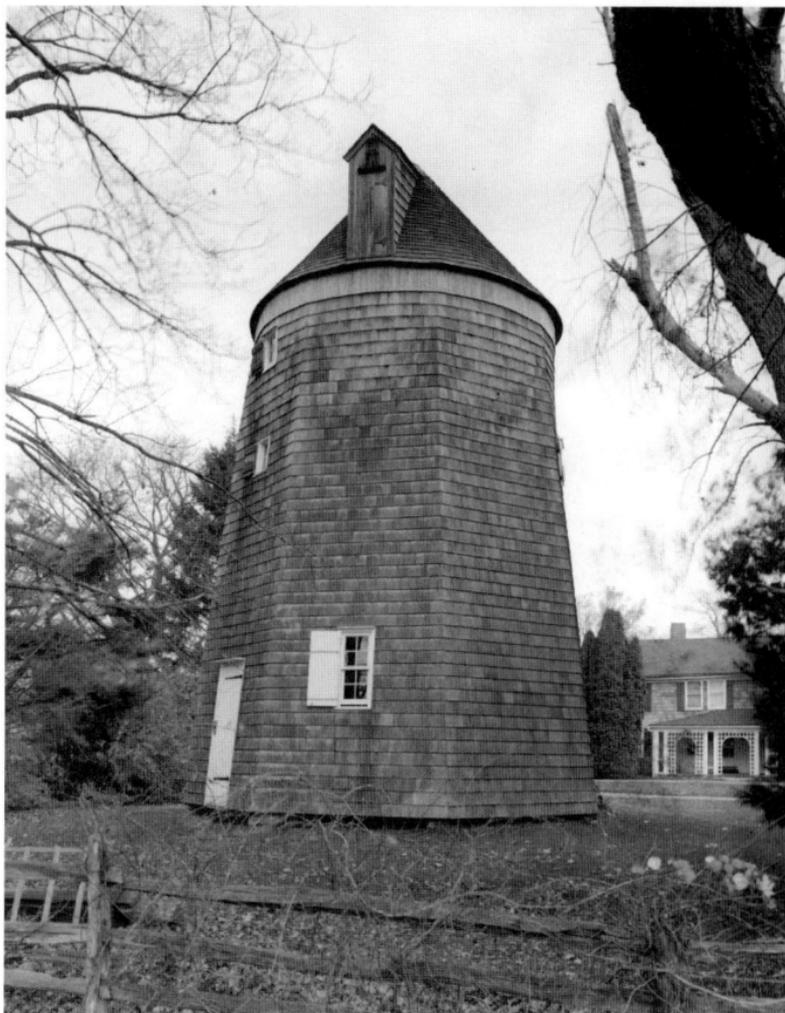

The Gardiner Windmill in East Hampton was built in 1804. Unlike most other Long Island windmills, it is located on its original site. It was built by East Hampton craftsman Nathaniel Dominy V, who is known to have built at least three other East End windmills. It replaced an earlier mill constructed in 1769 for Abraham Gardiner. John Lyon Gardiner, the seventh proprietor of Gardiners Island, was a part owner.

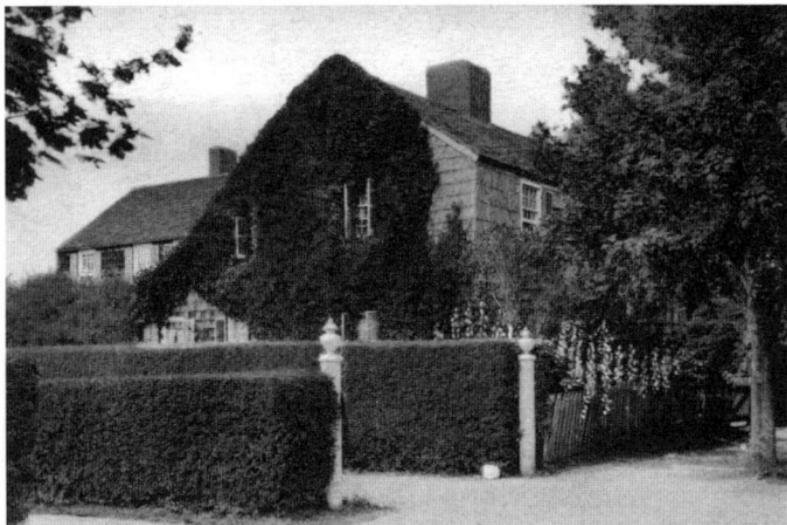

The "Old Hollyhocks" house on Main Street in Southampton was constructed in 1662. A greater concentration of seventeenth-century homes survived into the twentieth century on the East End of Long Island than in the rest of the New York Metropolitan Area.

Windmills and Historic Structures

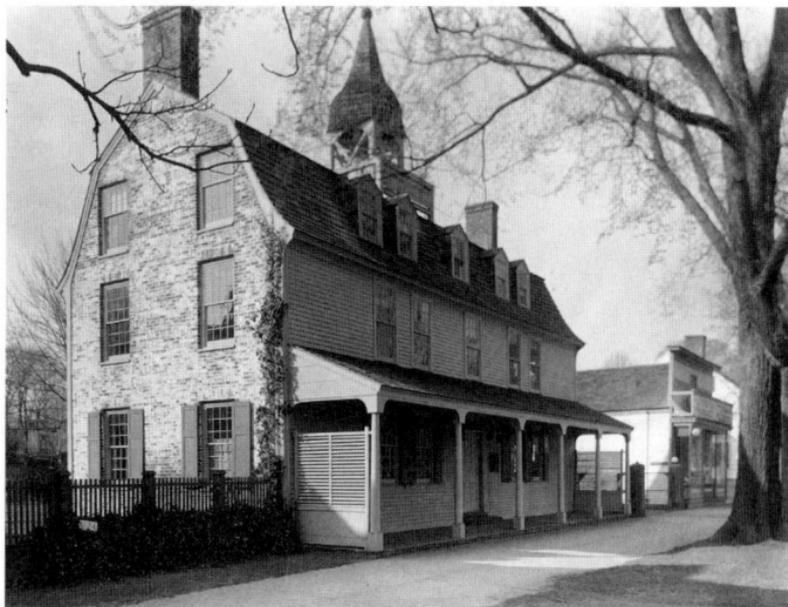

The historic Clinton Academy was constructed in 1784 at the urging of Samuel Buell, pastor of the Presbyterian church in East Hampton (who was to become the school's first headmaster). It was named after Governor George Clinton, who presented the academy with a bell. The academy had an excellent reputation and attracted students from far and wide. The building served its educational function for nearly one hundred years before being converted to a community center. It was then leased to the East Hampton Historical Society, the current tenant. The first teacher at the academy was William Payne, father of John Howard Payne.

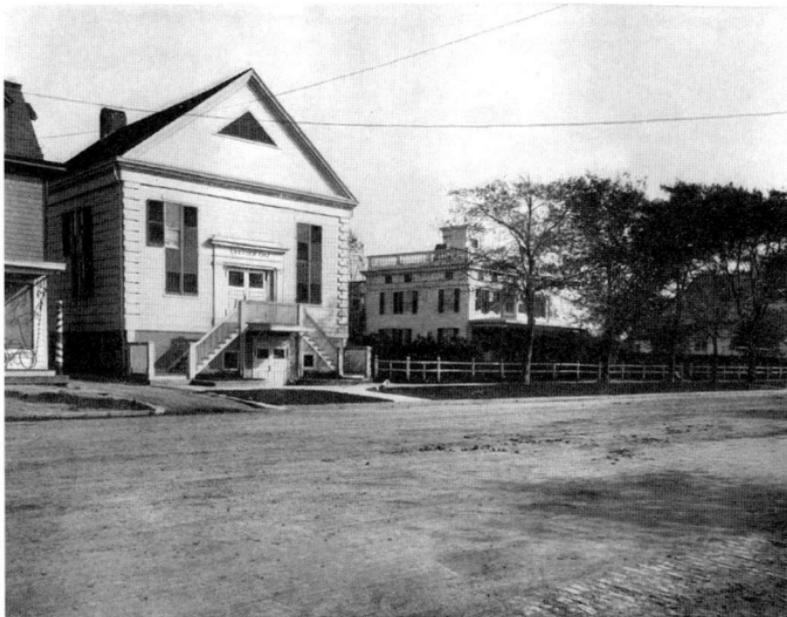

This church building in Southampton was built in 1707 on a thirty-six- by forty-six-foot lot. It was bought by Samuel L. Parrish toward the end of the nineteenth century, remodeled and made into a gymnasium. The wealthy benefactor then presented the renovated landmark (shown as it appeared about 1900) to the village.

Windmills and Historic Structures

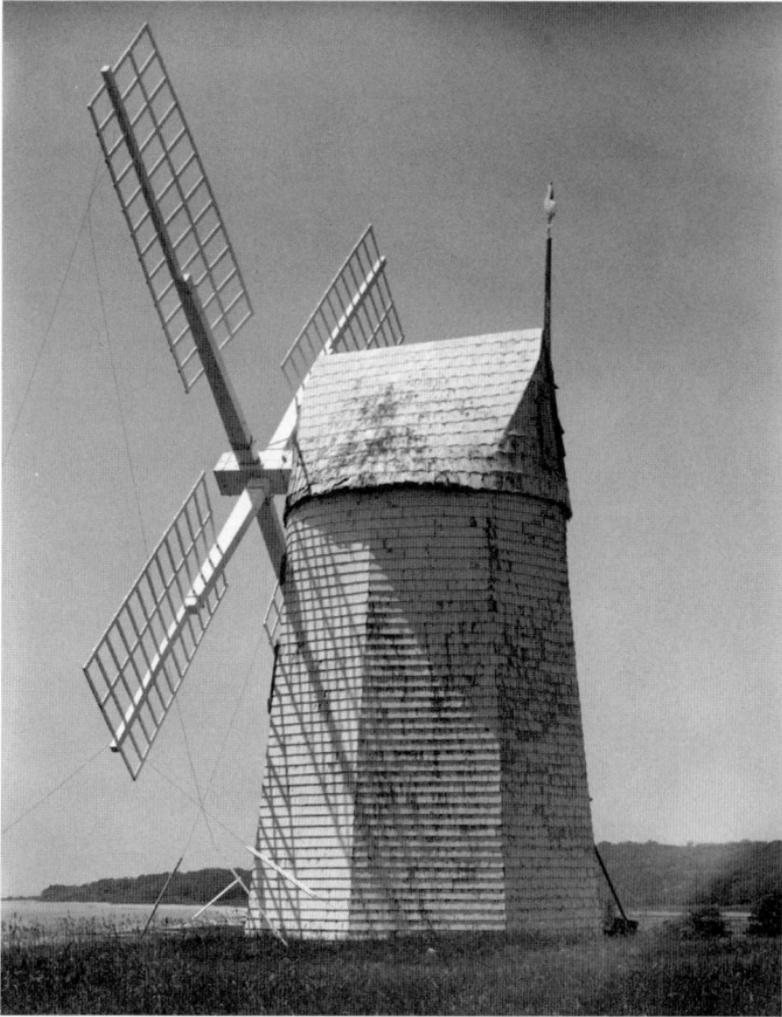

The Gardiners Island Windmill was built in 1795 by Nathaniel Dominy V for John Lyon Gardiner. It was made from local oak and mulberry wood, and the total cost was $773. For some unknown reason, the mill collapsed in 1815 but was promptly rebuilt by Dominy.

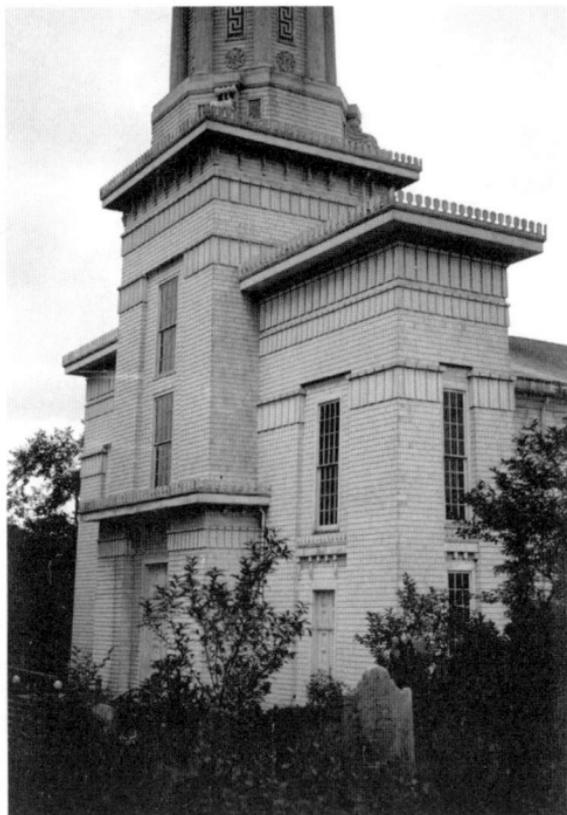

This page and next: Sag Harbor's First Presbyterian Church, also known as the "Old Whaler's Church," was built in 1844, with funding to pay the $19,000 bill coming from wealthy ship owners and captains in the prosperous whaling port. Designed by Minard LaFever in the Greek and Egyptian Revival styles, the building featured interesting details. The church was graced by a towering 185-foot-high steeple that was blown off during the 1938 hurricane. The Old Whaler's Church is a National Historic Landmark. The church is shown in two photographs taken during the mid-1930s, not long before the steeple toppled.

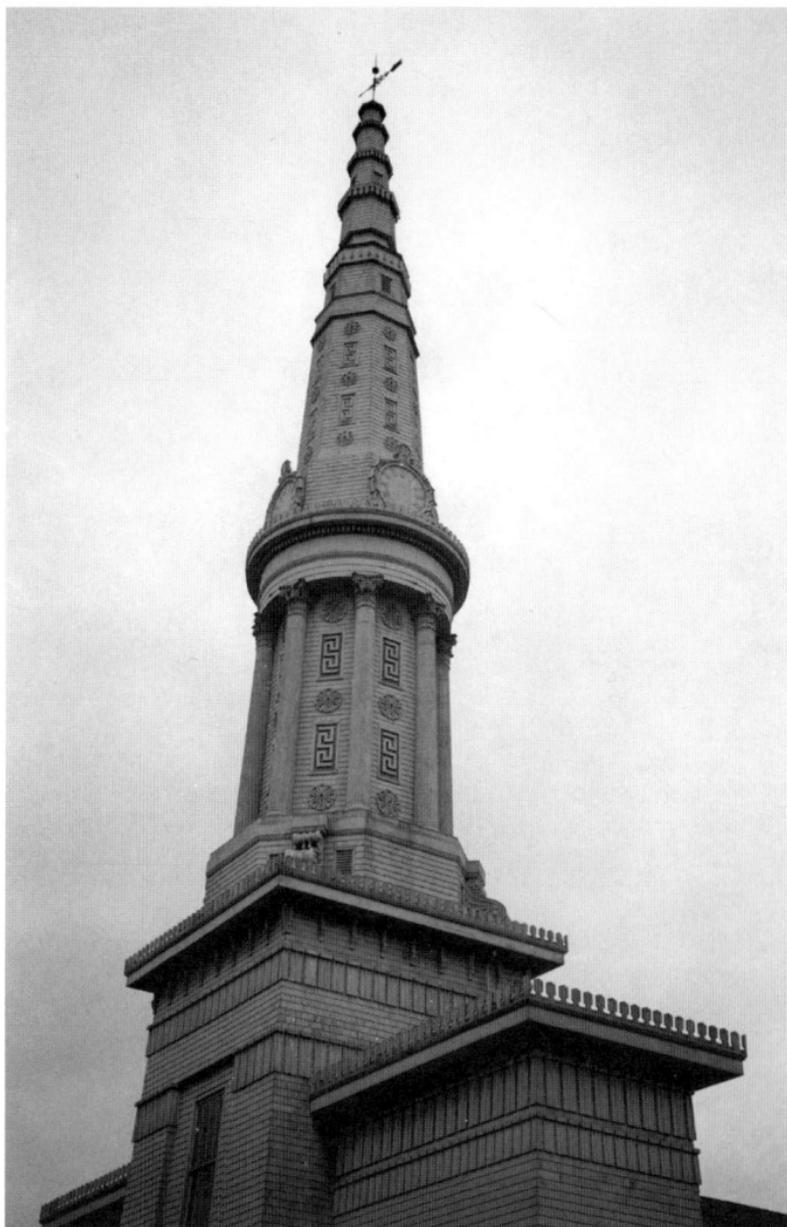

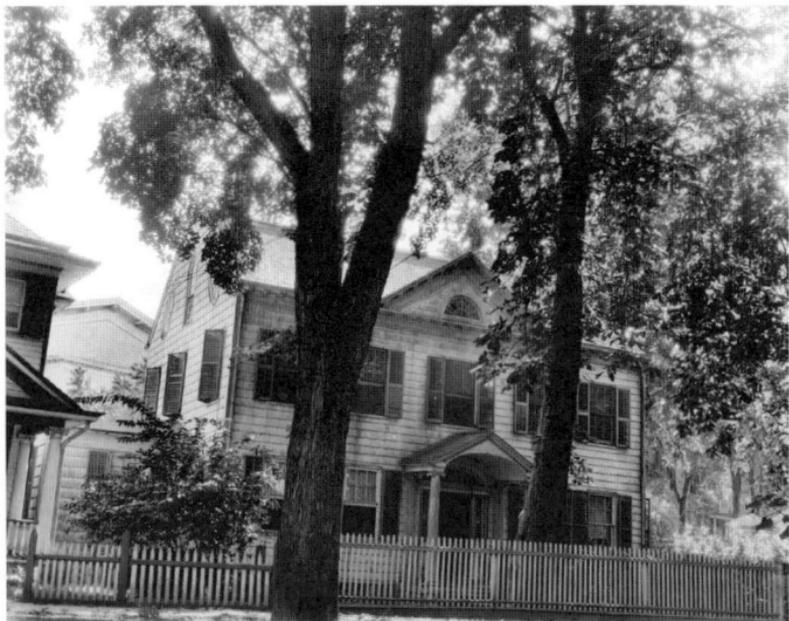

An old house in Sag Harbor is captured in this image from the 1930s. Like other South Fork communities, the village has been fortunate to preserve its historic heritage, and it still offers visitors many visual treats from times past.

Windmills and Historic Structures

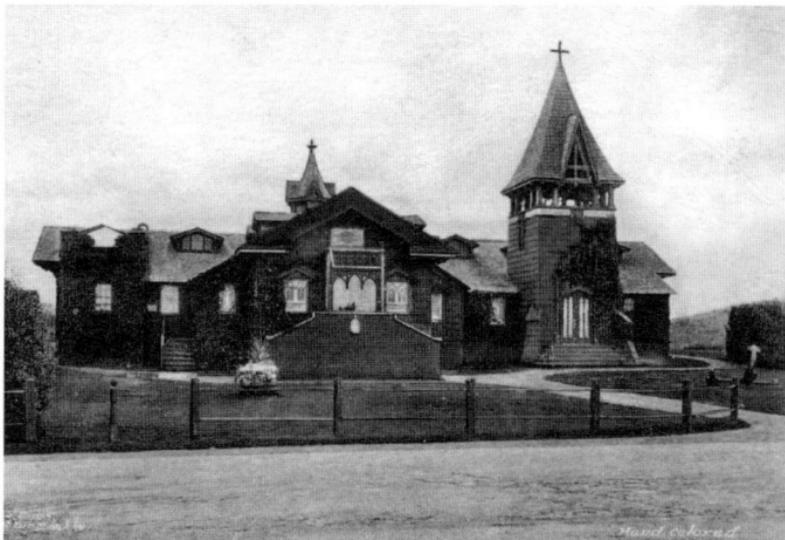

The St. Andrew's Dune Church was founded in 1879 as the St. Andrew's-by-the-Sea Church. The name was changed in 1884. The central part of the nave was originally the lifesaving station from Town Pond (Lake Agawam), built in 1851 and purchased by Dr. Gaillard Thomas specifically for use in building the church. Additions were made in 1883 and 1887. Because it is located so close to the water, the church was damaged by the 1938 hurricane.

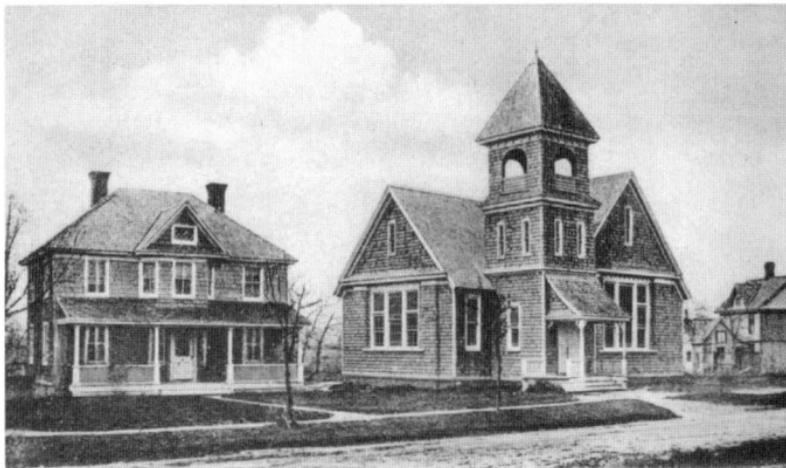

The Victorian Beach United Methodist Church on Mill Road in Westhampton Beach is located a couple of blocks from Aspatuck Creek. The church is seen here in 1906.

Windmills and Historic Structures

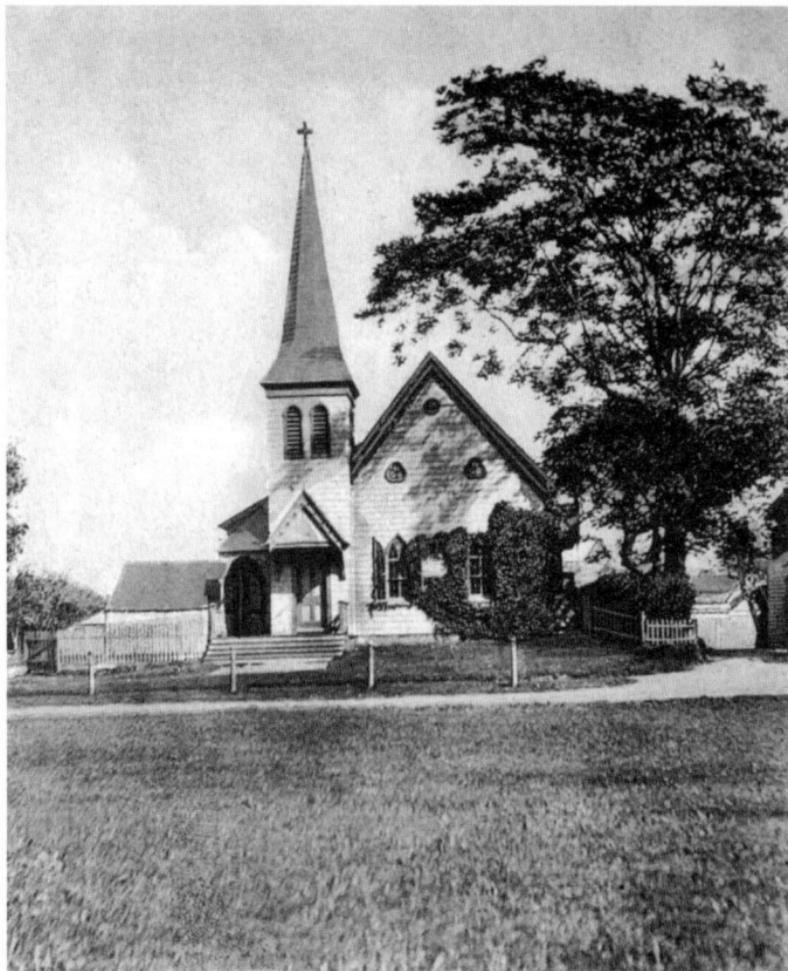

The wood-frame St. Luke's Episcopal Church was built in East Hampton in 1859, funded by a rather mysterious man named John Wallace, who had arrived from Scotland in 1840 but revealed little about his past. Only after his death was it discovered that he had fled Scotland when a warrant had been issued for his arrest. In 1910, a large new stone church was added. Designed by Thomas Nash, it was a replica of a church in Maidstone, England. The original building is seen here in 1906.

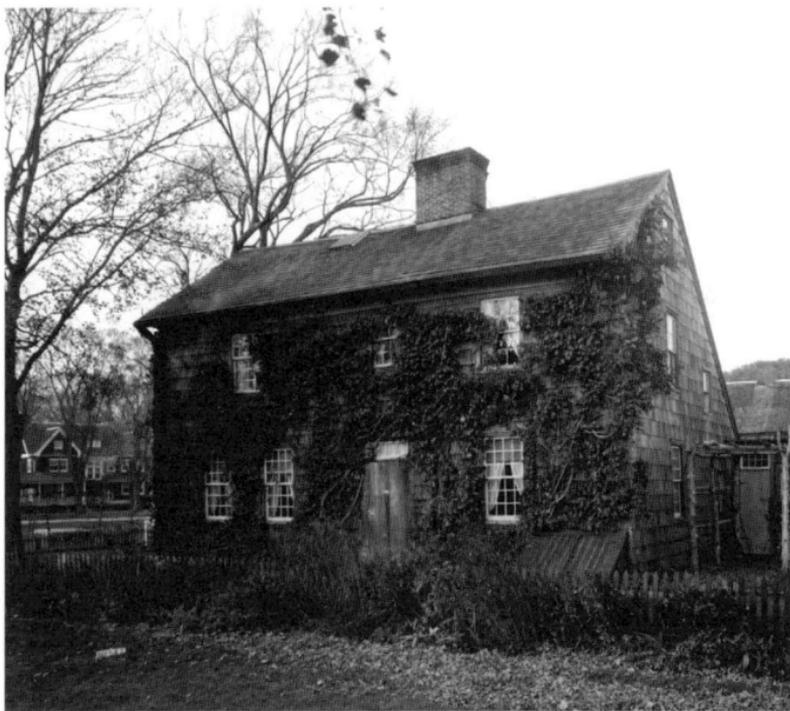

Home Sweet Home was the name given to the childhood home of John Howard Payne in East Hampton, after the popular song he wrote by the same name. The early eighteenth-century building was preserved and furnished with period pieces by early twentieth-century owner Gustav Buek.

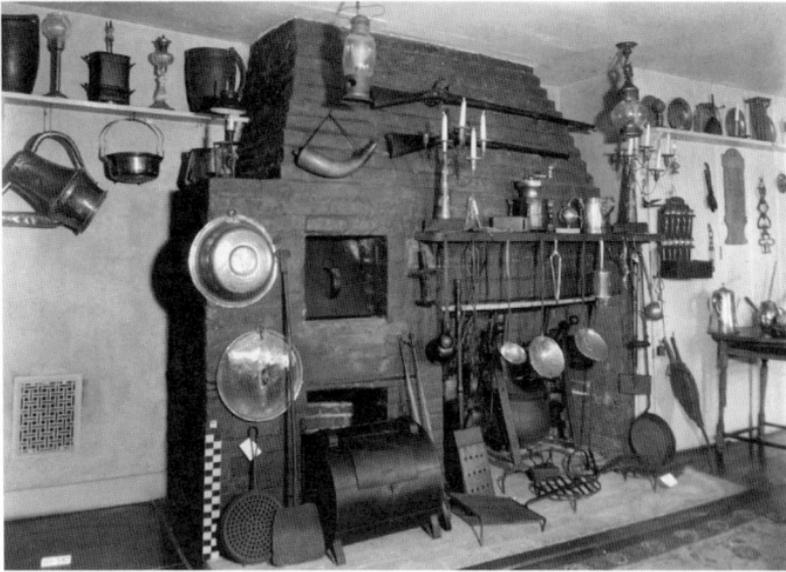

This photo shows the interior of Home Sweet Home in East Hampton, as it appeared during the 1930s, with authentic period furniture, tools and equipment.

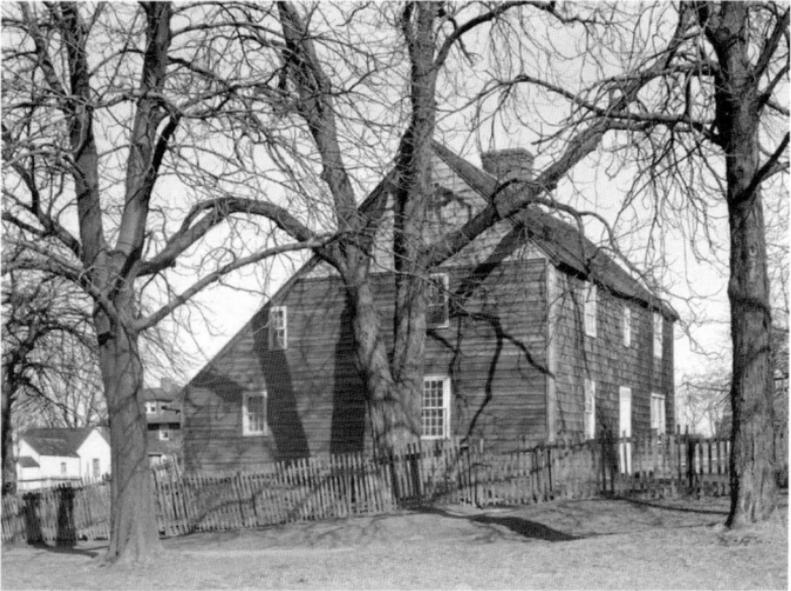

Mulford House was built by Josiah Hobart, circa 1680. Located on James Lane in East Hampton, it passed to the Mulford family in 1698 and remained in the family until 1948. It underwent a major restoration in 1950. Mulford House is located adjacent to the John Howard Payne House.

Windmills and Historic Structures

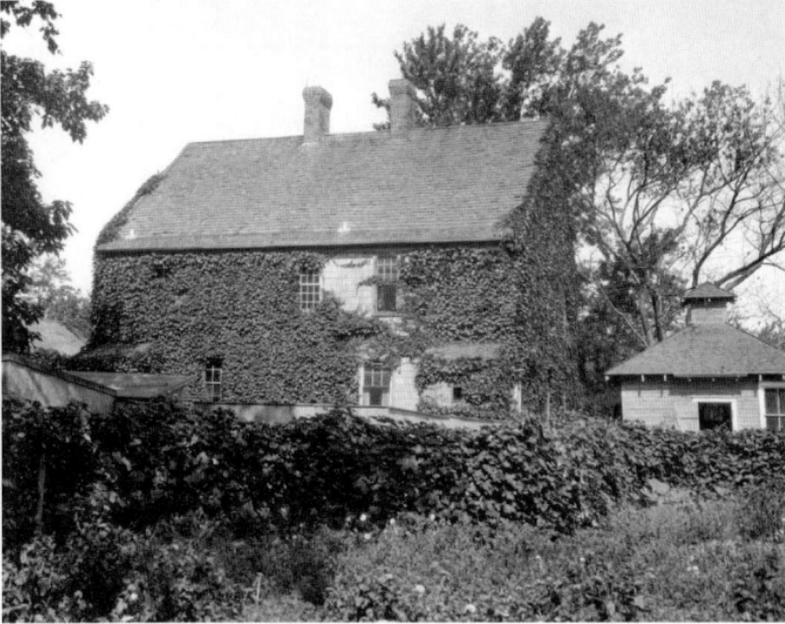

An unidentified old ivy-covered house in East Hampton was captured by a photographer from the government's Historic American Buildings Survey (HABS) during the 1930s. In some cases, HABS photographers were aware that the structures they were documenting were in imminent danger of being demolished.

Chapter 3

FAMOUS RESIDENTS
AND VISITORS

Childe Hassam
(1869–1935) was
an American
Impressionist
born in
Massachusetts.
He visited the
South Fork
several summers
before purchasing
a home called
Willow Bend on
Egypt Lane in
East Hampton
from the widow
of fellow artist
Gaines Ruger
Donoho. He
enjoyed the
picturesque
scenery and
painted several
landscapes
showing life on
the South Fork.

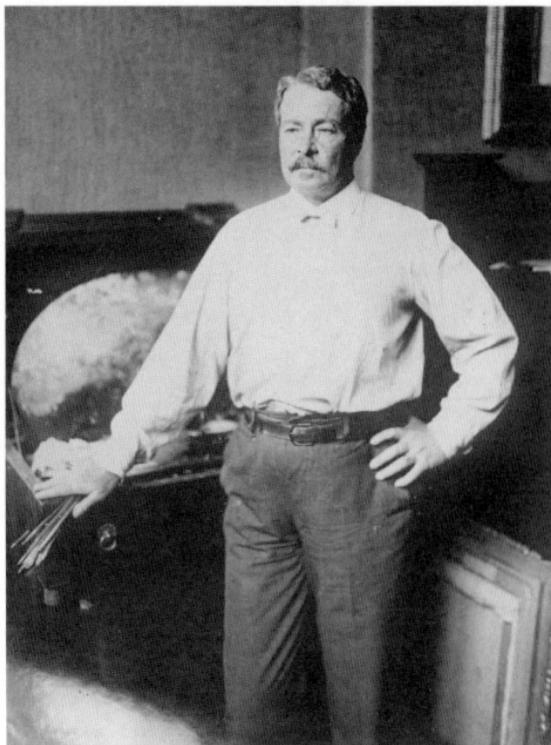

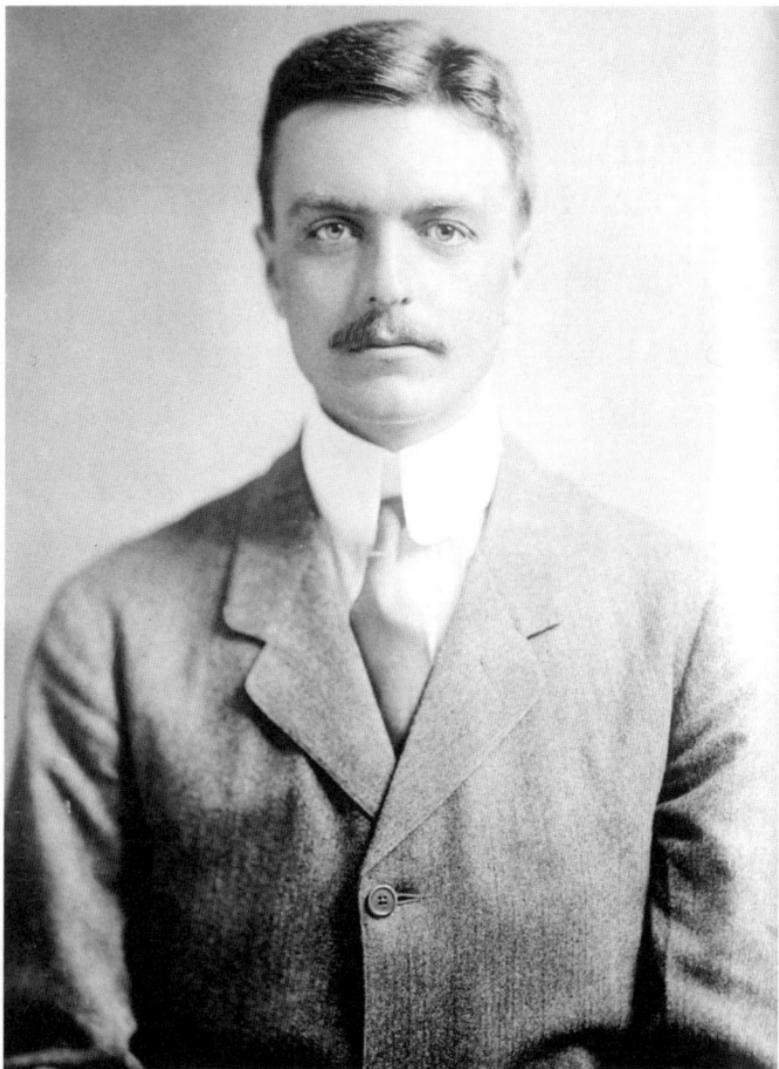

Lathrop Brown (1883–1959) was a close friend of Franklin Delano Roosevelt, with whom he attended the Groton School when they were both teenagers. Brown was elected as a congressman from New York and served from 1913 to 1915. He had a home in Southampton and also Montauk.

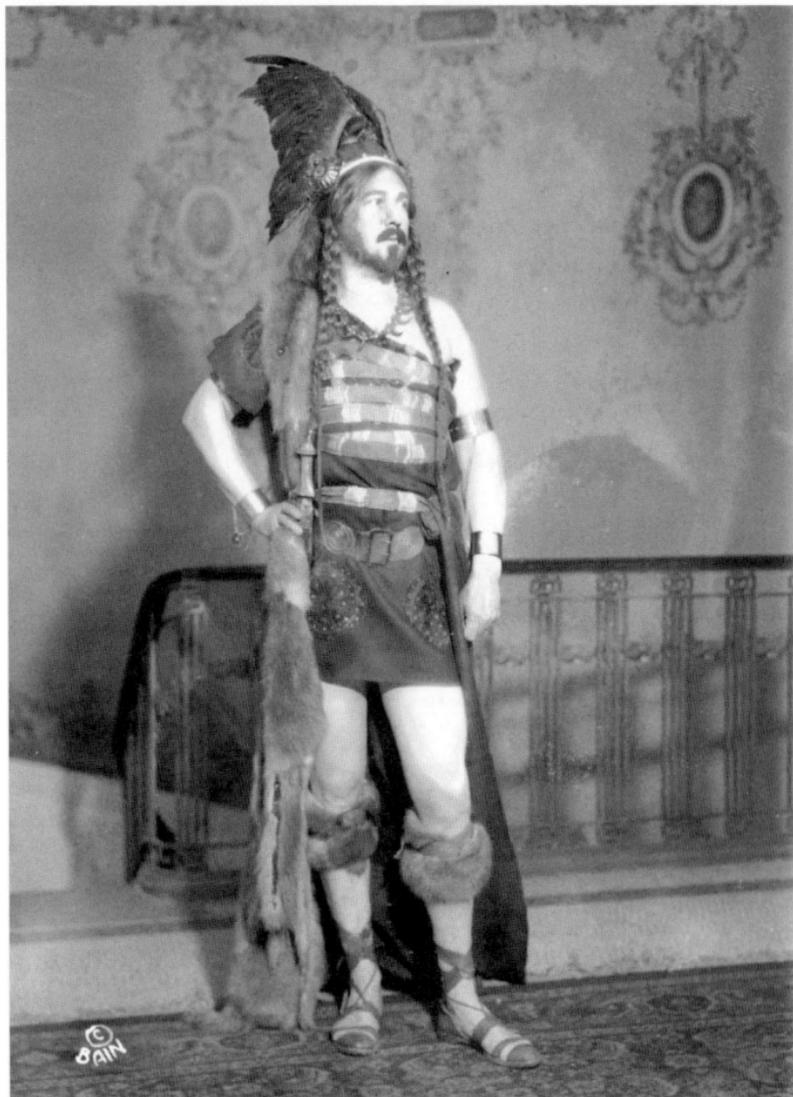

Albert Herter (1871–1950) was an artist who owned the Creeks estate, a structure designed by the famed architect Grosvenor Atterbury and completed in 1899. The home was situated fronting Georgica Pond in East Hampton and was later owned by Ronald Perelman.

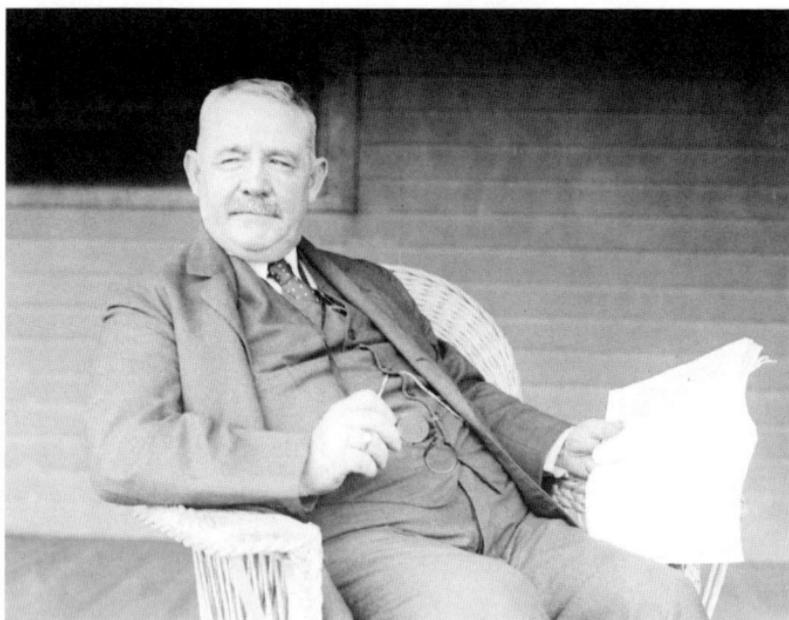

Edward Everett McCall (1863–1924) was a New York State Supreme Court justice from 1903 to 1910. He was also chairman of the Public Service Commission and the Democratic candidate for New York City mayor in 1913. He had a summer home in East Hampton.

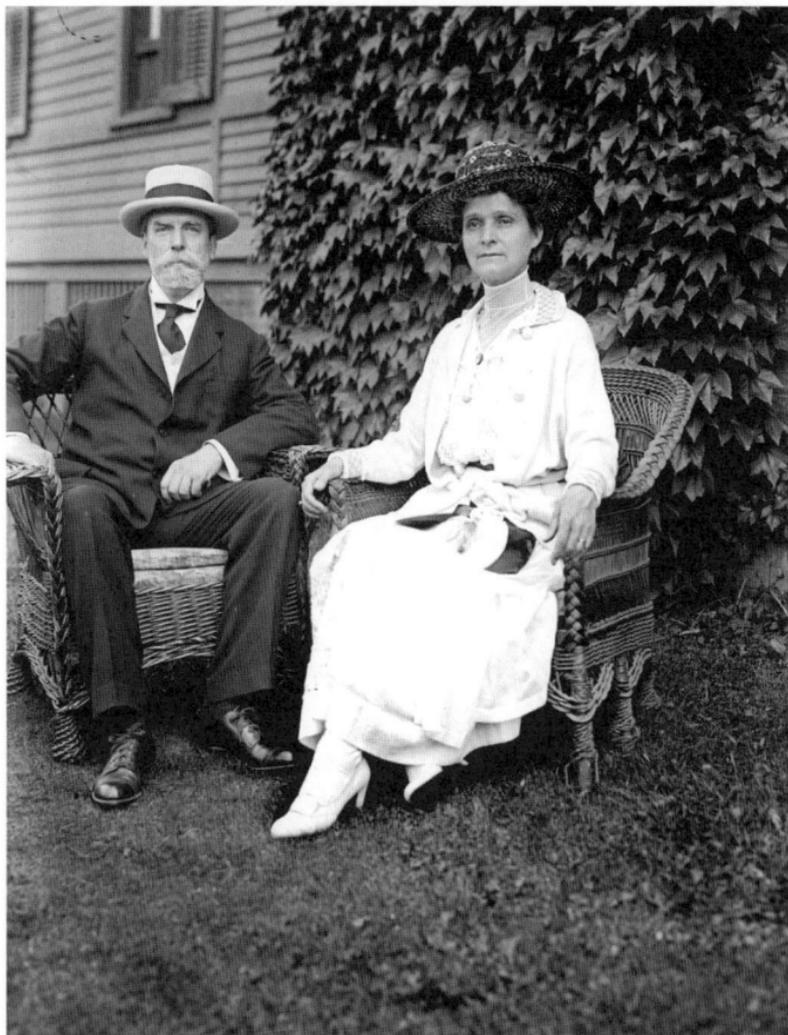

Charles Evans Hughes (1862–1948) was governor of New York from 1907 to 1910, before his appointment to the United States Supreme Court. In 1916, he resigned from the court to be the Republican nominee for president. During that exciting summer of 1916, Hughes and family spent much time in Bridgehampton at Tremedden, the home of one of his relatives. He is seen here sitting with his wife outside of Tremedden.

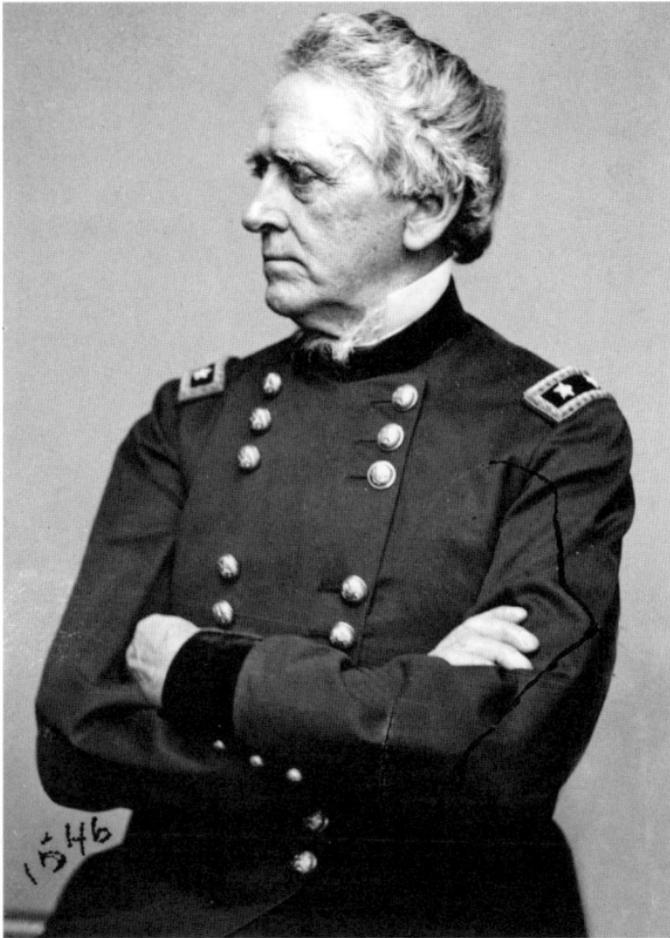

John Adams Dix (1798–1879) was secretary of the treasury (briefly) before serving as a noted Civil War general and then later as governor of New York State (1873–74). Dix had a summer home built in Westhampton in 1870. According to his son, "His first intention was to construct a little shooting box, or mere cottage for sportsmen, but it ended in the erection of a mansion large enough to hold us all" on fifty acres of land. He called the home Ketchabonneck. He celebrated his eightieth birthday there in 1878.

Famous Residents and Visitors

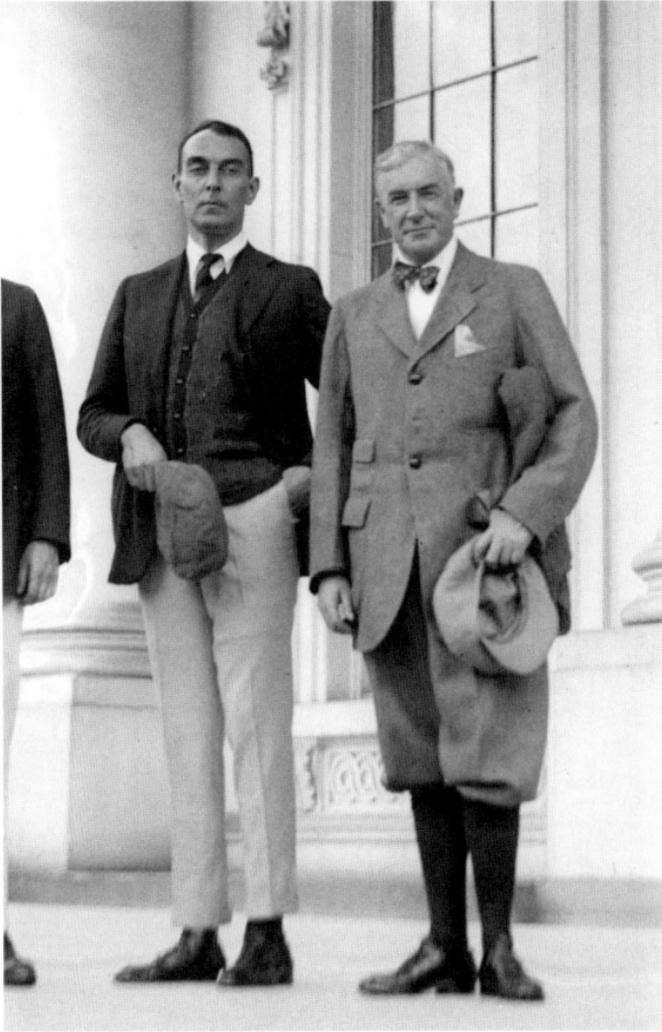

Ring Lardner (1885–1933) was a popular sports and fiction writer. Born in Michigan, he moved to East Hampton in the 1920s, along with other writers such as Grantland Rice. By that time, he was well known for his columns and his short stories, as well as the novel *You Know Me Al* (1916). Ring Lardner died in East Hampton at the age of forty-eight.

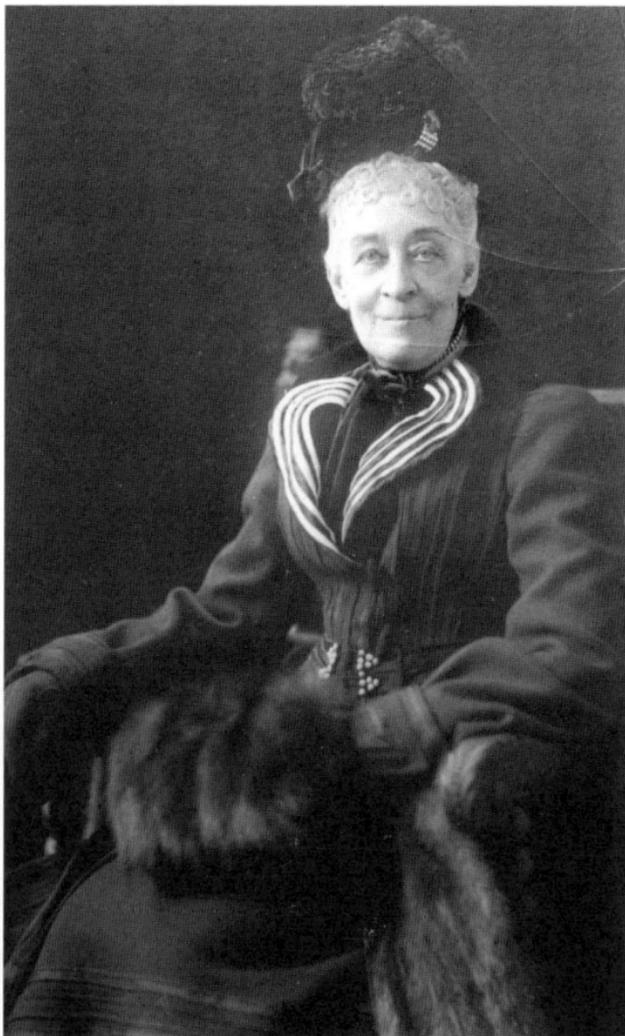

Margaret Olivia Slocum Sage (1828–1918) was the wife of millionaire Russell Sage. She was originally from Sag Harbor and spent much time there after her husband died in 1906, leaving her a huge fortune. She was well known in Sag Harbor for her philanthropy. Mrs. Sage was a descendant of the Pilgrim Myles Standish.

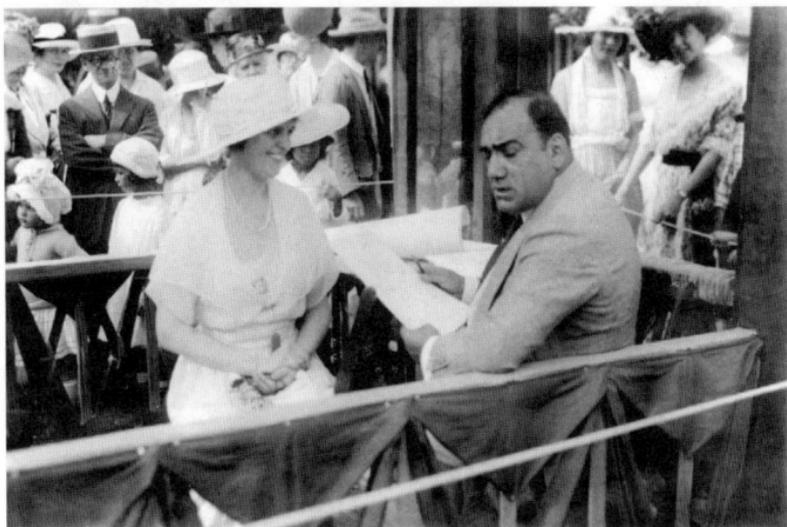

Enrico Caruso (1873–1921) was an Italian-born opera star. Toward the end of his life, he and his wife had a summer home in East Hampton. The house was robbed in June 1920, and $400,000 worth of valuables were taken. He is seen here sketching Mrs. Albert Gallatin at a charity fair in Southampton in August 1920.

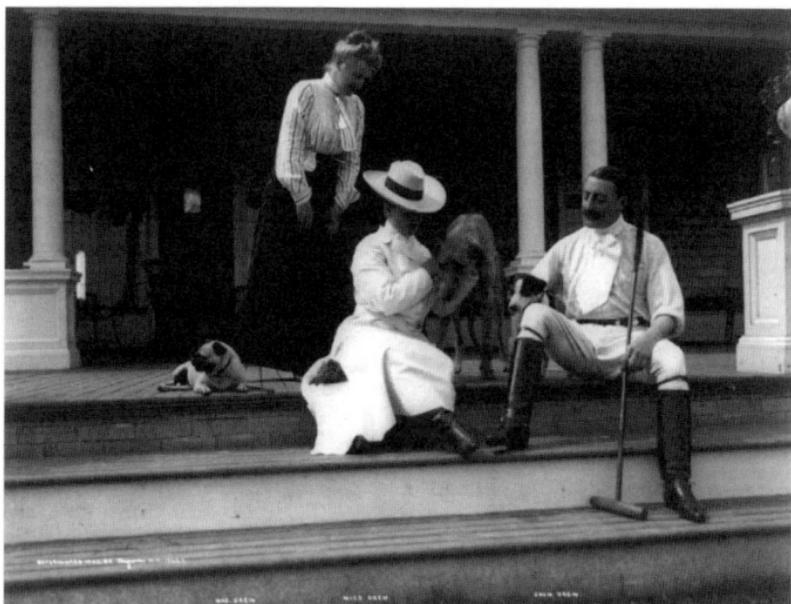

John Drew (1853–1927) was a famous American stage actor. He had a cottage called Kyalami at East Hampton. Drew was the uncle of John, Ethel and Lionel Barrymore. The actress Drew Barrymore is named after him. The Drew Theater, also named in his honor, was opened in 1931. He is seen here at his cottage with wife Josephine and daughter Louisa in 1902.

Famous Residents and Visitors

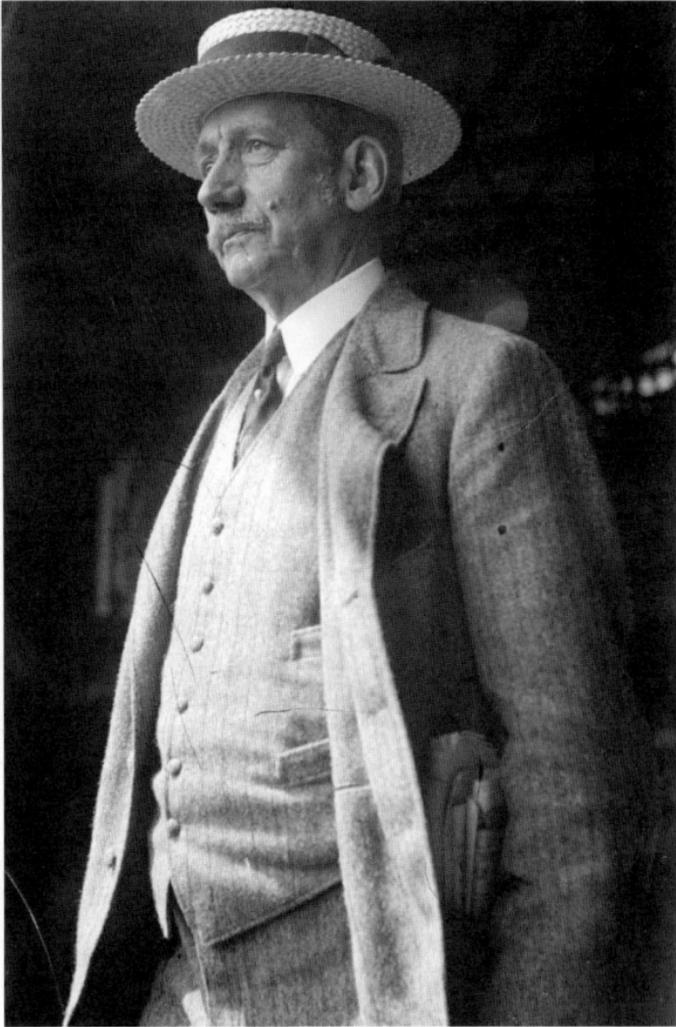

Elihu Root (1845–1937) was secretary of war under
Presidents William McKinley and Theodore Roosevelt and
then secretary of state under President Roosevelt. From 1909
to 1914, he served as a United States senator. He won the
Nobel Peace Prize in 1912. Root had a summer home built
in Southampton during the 1890s.

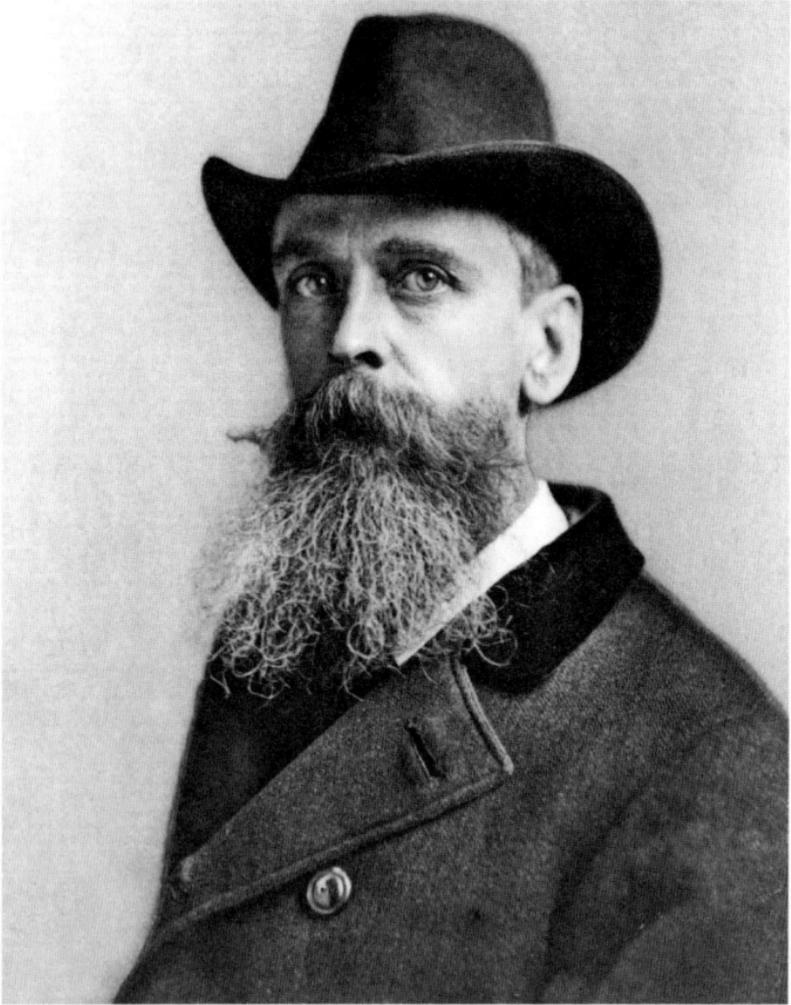

Thomas Moran (1837–1926) was a painter renowned for his nineteenth-century canvases of the American West. He had a home and studio in East Hampton from the mid-1880s until 1922, when he moved to California. Other turn-of-the-twentieth-century painters who were attracted to the South Fork included William Merritt Chase. A new wave of artists would arrive during the 1940s and 1950s that included the De Koonings and Jackson Pollock.

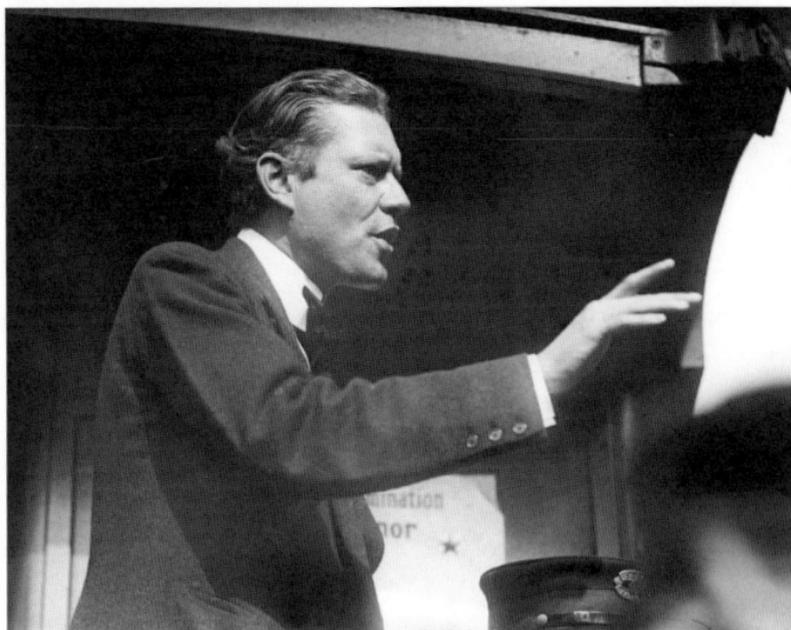

When Lieutenant Governor Lewis Stuyvesant Chanler (1869–1942) campaigned for governor of New York, he spent some time on Long Island. He is seen here campaigning at Southampton in 1908. He lost the election to the Republican candidate, Charles Evans Hughes, who spent the summer in Bridgehampton in 1916 while campaigning for president.

SUMMER RESIDENCES AND HOTELS

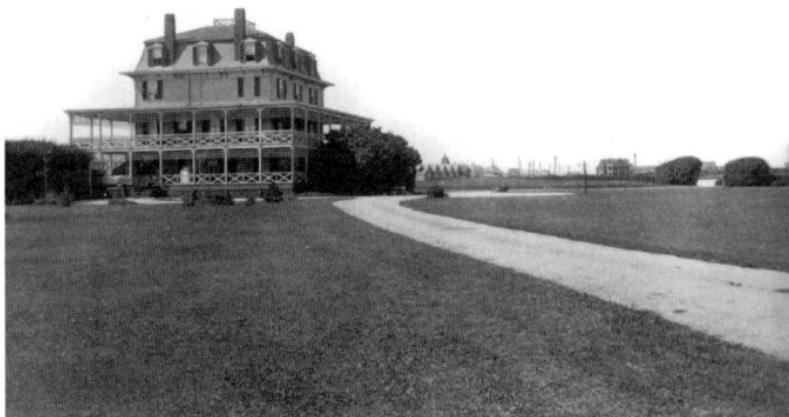

Dr. Gaillard Thomas was a respected gynecologist from New York City. He was convinced by a patient's husband to visit Southampton and liked it so much that he moved there in 1877. With the growing popularity of the area, he soon found plenty of patients. His son Theodore was born in Southampton in 1880.

This image of New York State Supreme Court justice Edward E. McCall's summer home in Easthampton likely dates to the 1910s. The house, originally owned by one C.C. Rice, burned down in 1927.

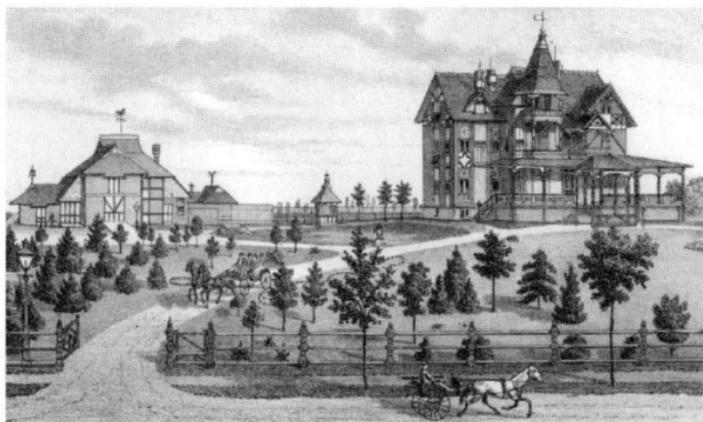

Tremedden was built in 1878 in Bridgehampton by Richard Esterbrook, heir to the Esterbrook Pen Company fortune. Located at Ocean and Sagaponack Roads, the ornate Victorian house had twenty-four rooms. Unfortunately, it was demolished in 1939. Tremedden and its grounds are depicted here as they appeared in 1882.

Summer Residences and Hotels

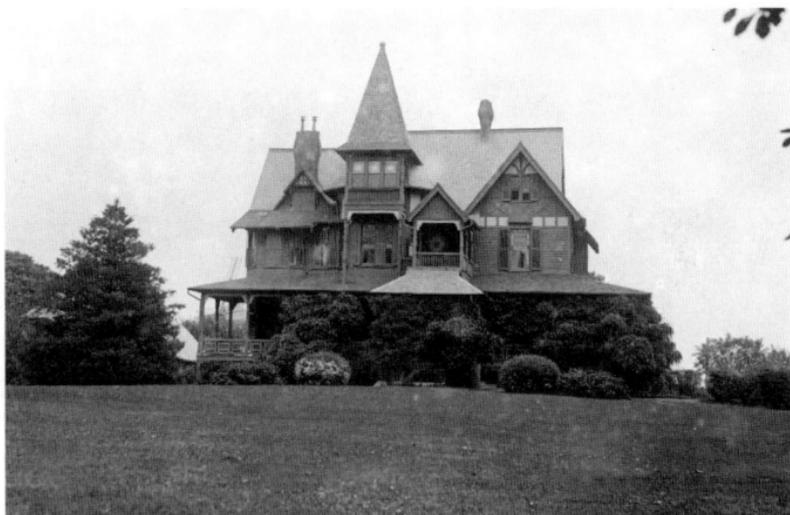

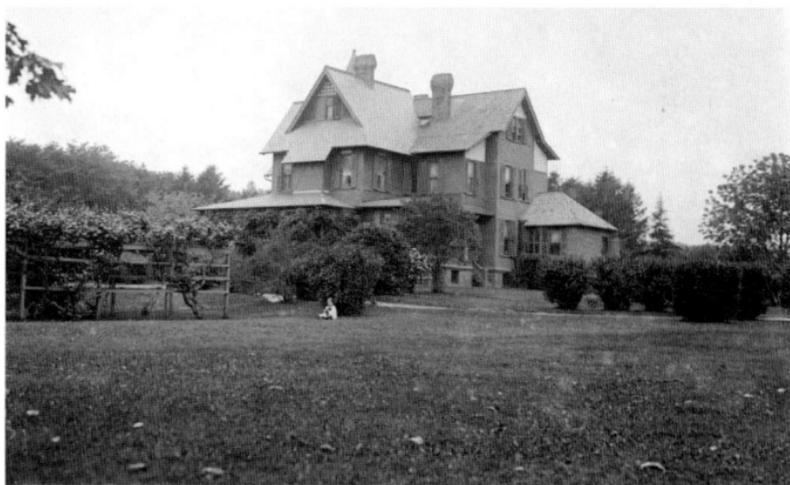

This page: Tremedden is seen from two different vantage points in these 1916 photographs, taken during the summer when presidential candidate Charles Evans Hughes lived there. When he first arrived at Bridgehampton on June 24, 1916, he was greeted with fanfare by hundreds of local citizens.

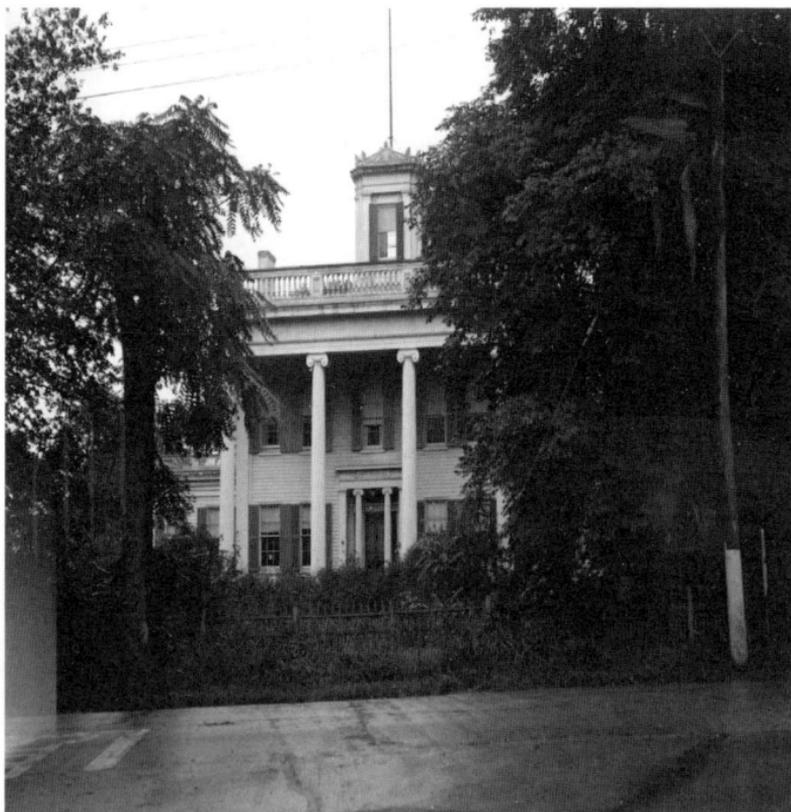

Hampton House (also known as the Hopping Inn), a Greek Revival treasure on Montauk Highway in Bridgehampton, was built circa 1820 by Abraham Rose and enlarged circa 1840 by Nathaniel Rogers. For many years beginning in the late nineteenth century, it was used as a hotel. It was damaged in the 1938 hurricane but survived. It is listed on the National Register of Historic Places and is now owned by the Bridgehampton Historical Society.

Summer Residences and Hotels

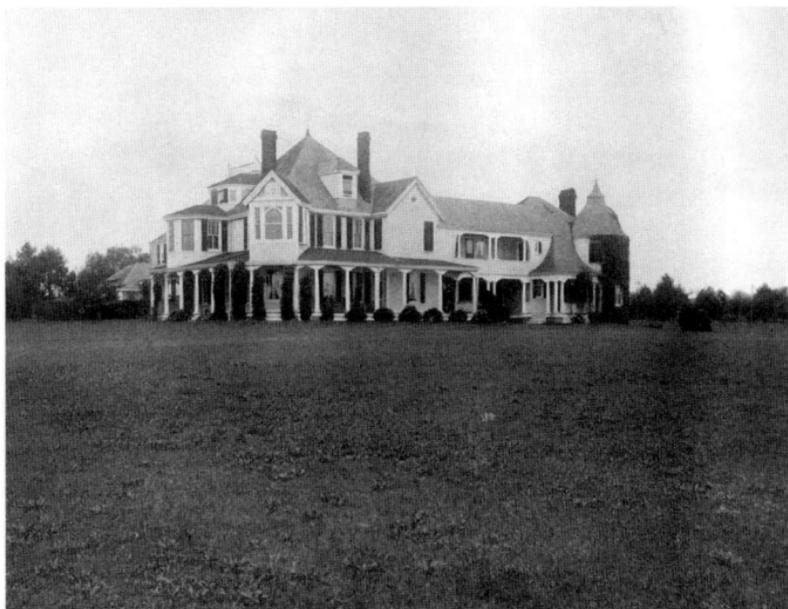

Ox Pasture was built by Salem H. Wales, a former candidate for mayor of New York City and president of the New York City Board of Park Commissioners. He bought ten acres on Lake Agawam and built his house there. Wales was the father-in-law of the diplomat Elihu Root.

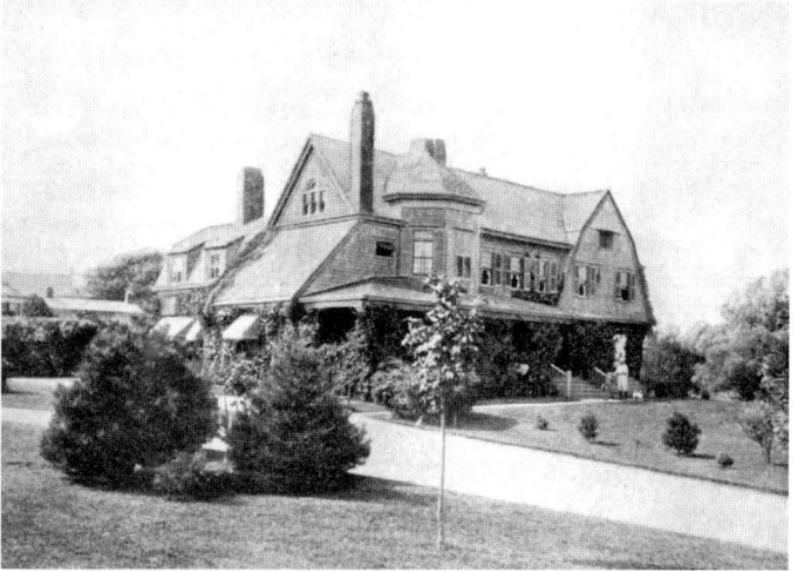

Pudding Hill in East Hampton was the estate of Dr. Everett Herrick (died 1914), who had the house built in 1887 on the site of an older home by the same name. Herrick Park is named after the family. This view dates to about 1900.

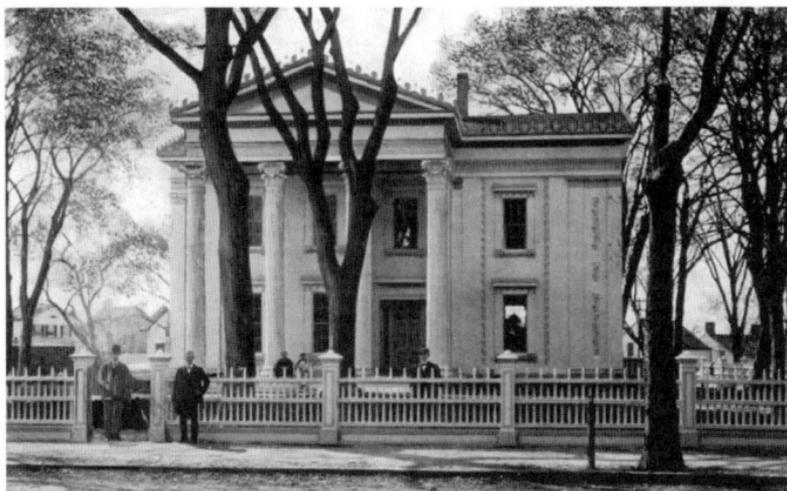

This photograph shows the home of Mrs. Russell Sage (1828–1918) in Sag Harbor. The wealthy Mrs. Sage funded several projects for the people of Sag Harbor, including a park and a library. At one point, she even had a quantity of soil moved from New Jersey to her property in Sag Harbor in order to better grow her prized ferns.

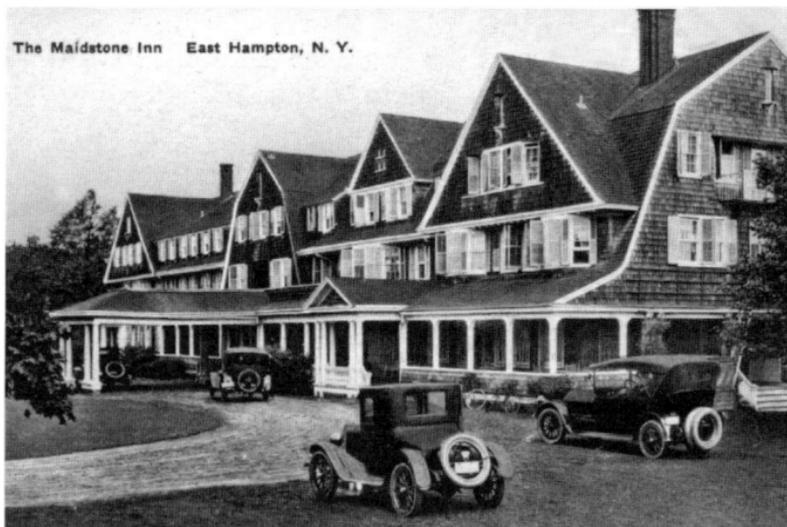

The Maidstone Inn East Hampton, N. Y.

The Maidstone Inn was built in 1898 on Maidstone Lane in East Hampton, a few years after the Maidstone Club was founded on the same street. In the early years of the twentieth century, the *New York Times* referred to it as the "most popular hostelry of the south fork." The building burned down in 1935. This image dates to the 1920s.

Summer Residences and Hotels

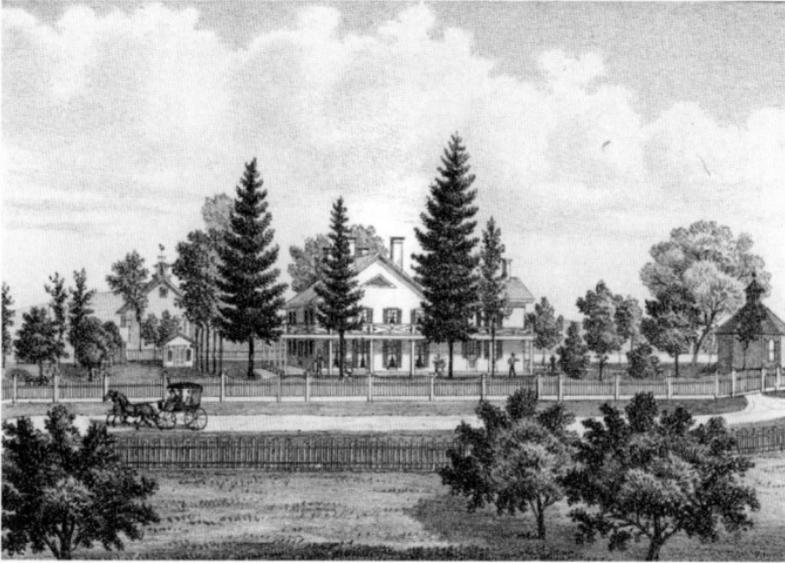

This image shows the summer residence of Asher C. Havens on Shelter Island, circa 1882. The family had deep roots on the island but also had property in North Haven. The original Shelter Island property was one thousand acres, but by the 1880s it was down to eighty-five acres. The home shown in the image was built in 1743.

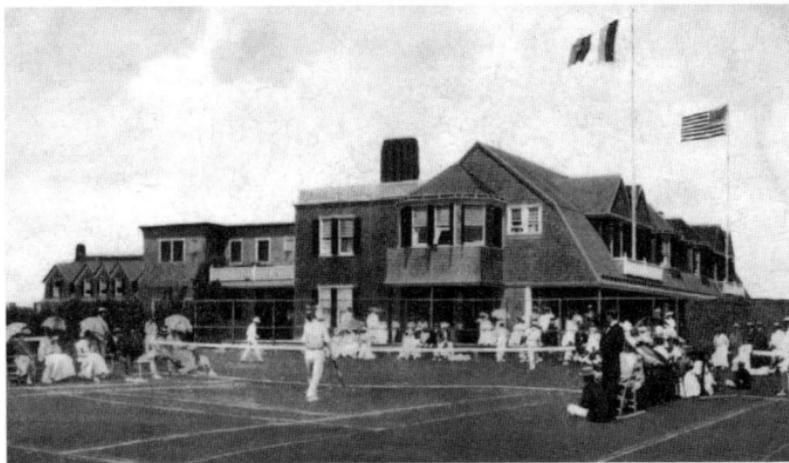

This image depicts a tennis match at the Meadow Club in Southampton, circa 1907. Tennis was a popular sport on the South Fork during the early twentieth century, and the Meadow Club was formed in 1883 to cater to the tennis needs of the growing summer colony. During the 1880s and 1890s, the Long Island Tennis Championships were played at the Meadow Club.

Summer Residences and Hotels

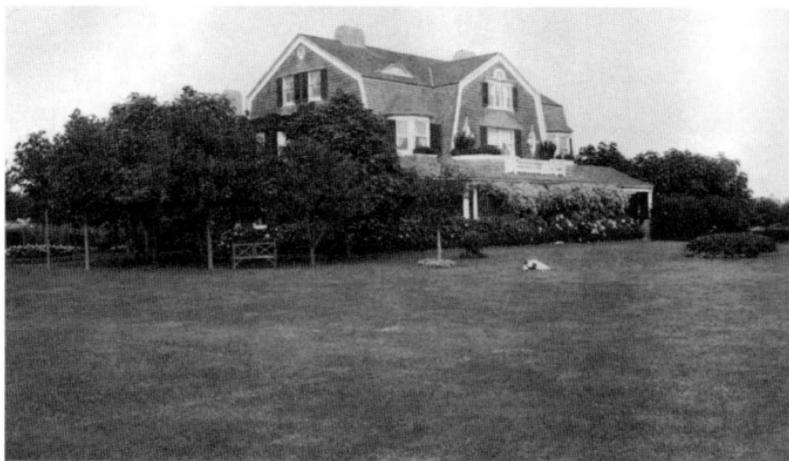

Shown here is Darene, the shingle-style home of Mrs. M.B. Cauldwell and her son John on Ox Pasture Lane in Southampton, circa 1900.

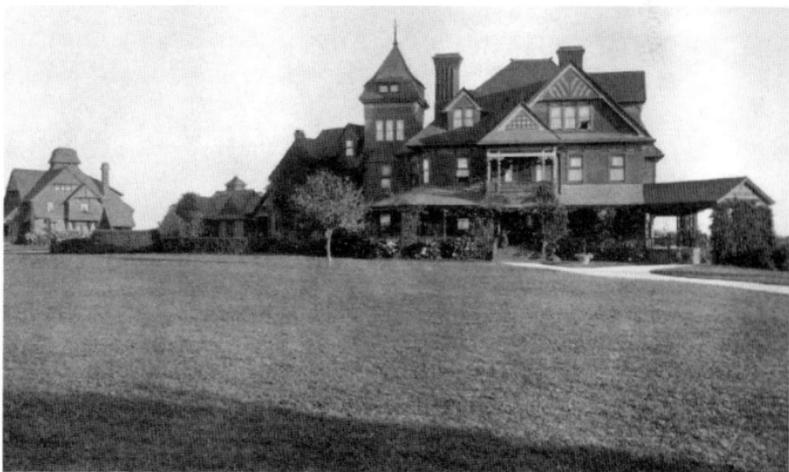

The Dr. E.L. Keyes home called Grass Land was built in the popular Queen Anne style on eleven acres fronting Mecox Bay in Water Mill. Dr. Keyes purchased the home circa 1895 (seen here as it appeared in about 1900).

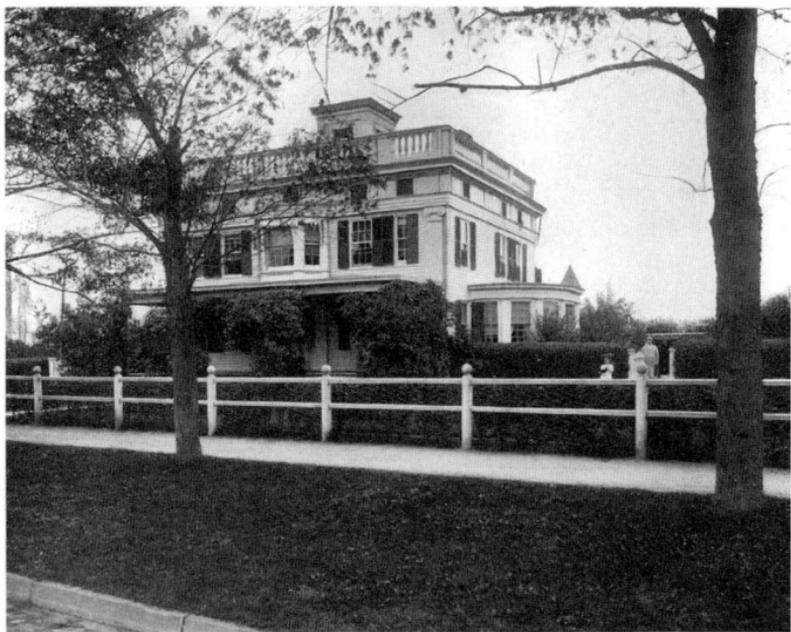

The old Captain Rogers homestead in Southampton would later become the home of Samuel L. Parrish, a man whose philanthropic efforts during the late nineteenth century helped fund numerous cultural and institutional projects for the people of Southampton. In 1943, the building was purchased by the village and was used by the Red Cross and the Colonial Society (founded 1898).

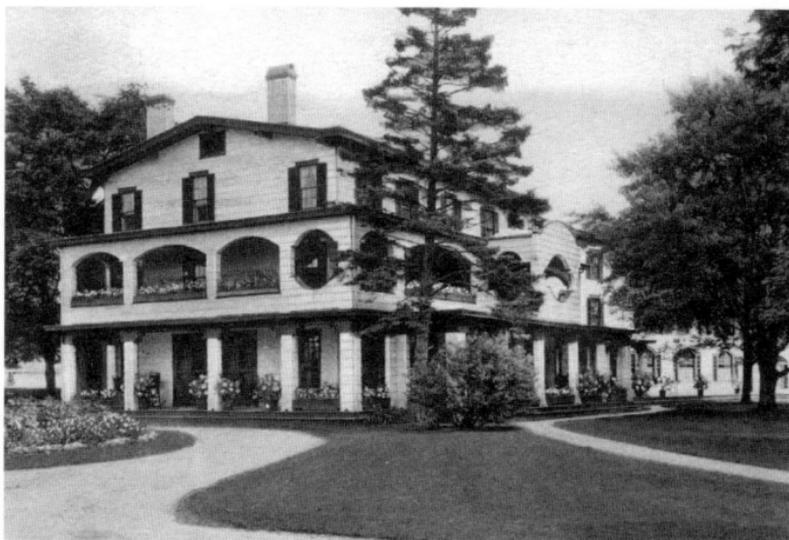

Howell House at Westhampton Beach is shown in an image dating to the 1920s. This famous hotel was built about 1866 at Beach Road and Main Street and was the first hotel in the community, with Mortimer D. Howell as the proprietor. The showman P.T. Barnum had visited the area and urged the construction of such a hotel. A railroad station came to Westhampton in 1870, and with it assurance that Howell House would enjoy a long and active life as a resort destination.

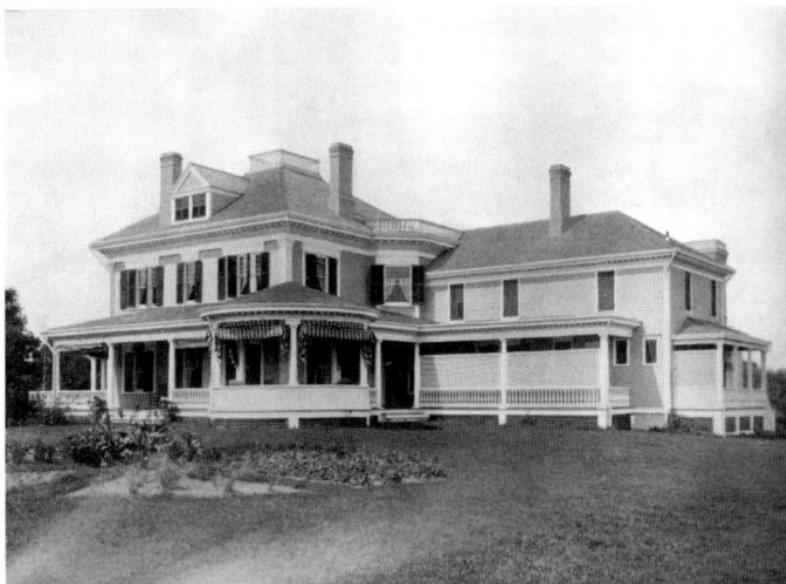

The Charles G. Thompson summer home in East Hampton, seen here circa 1900, was on a property that fronted Ocean Avenue and extended to Hook Pond. The population of East Hampton village in 1880 was 807. By 1902, it had risen to 1,600 due to its growing popularity both as a resort and as a year-round residence.

Summer Residences and Hotels

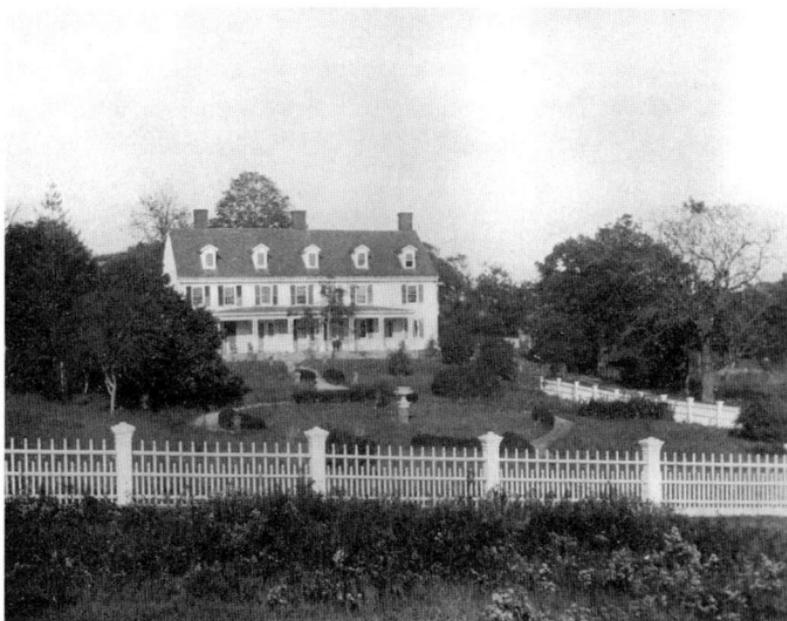

The Gardiner homestead on Gardiners Island is seen in this photograph from about 1900. The Gardiner family retained its ownership of the island for hundreds of years, throughout numerous generations of Gardiners. Many of the Gardiners did not remain on the island all their lives; rather, they lived or had business in the Hamptons.

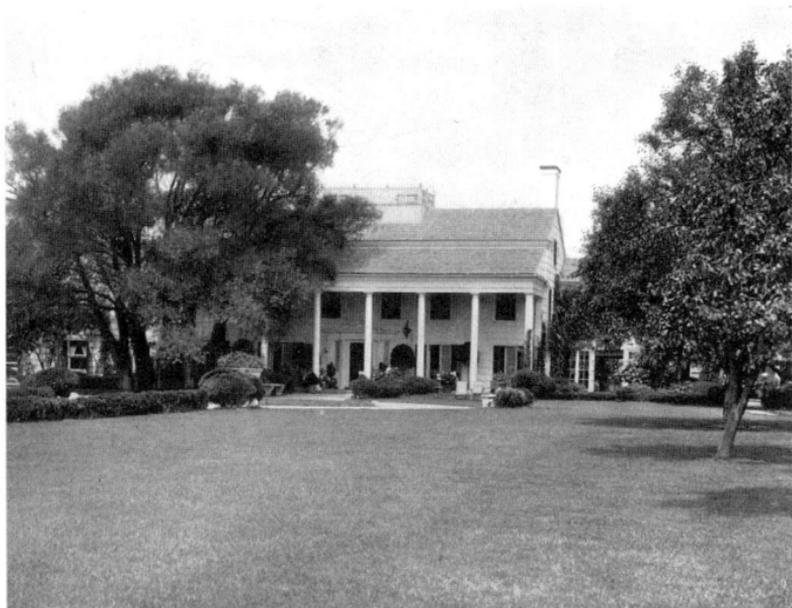

The Orchard was the home of James Lawrence Breese in Southampton. Designed by his close friend Stanford White (of McKim, Mead and White), the Colonial-style home sat on thirty acres and is seen here in 1906 just after its completion. Breese was a bohemian amateur photographer, automobile racer and the nephew of inventor Samuel F.B. Morse.

Summer Residences and Hotels

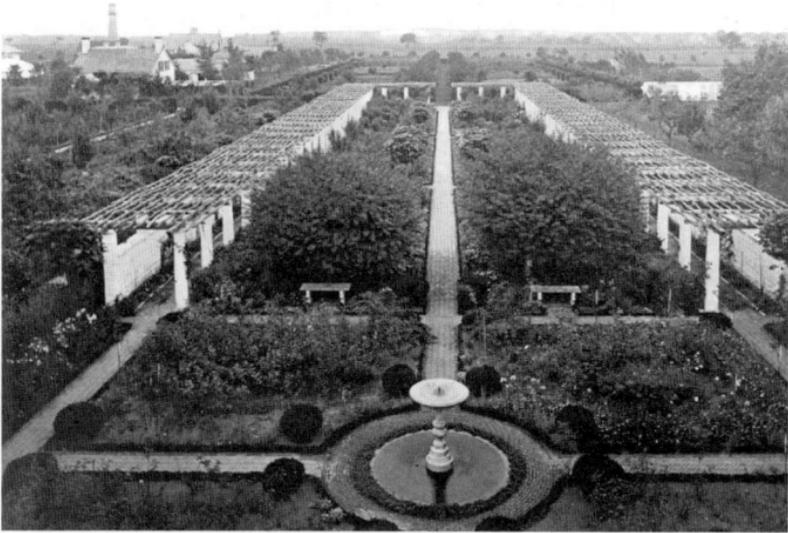

The grounds of the Orchard included a rose garden, fountain, pergola, gardener's cottage, icehouse, machine shop, carriage house, stable, barn, greenhouses, garage and shooting tower for shooting clay pigeons. Outside of the shooting tower, the number and type of outbuildings was fairly typical for an estate of this size. The gardens are shown here in 1906 in a view looking out from the house.

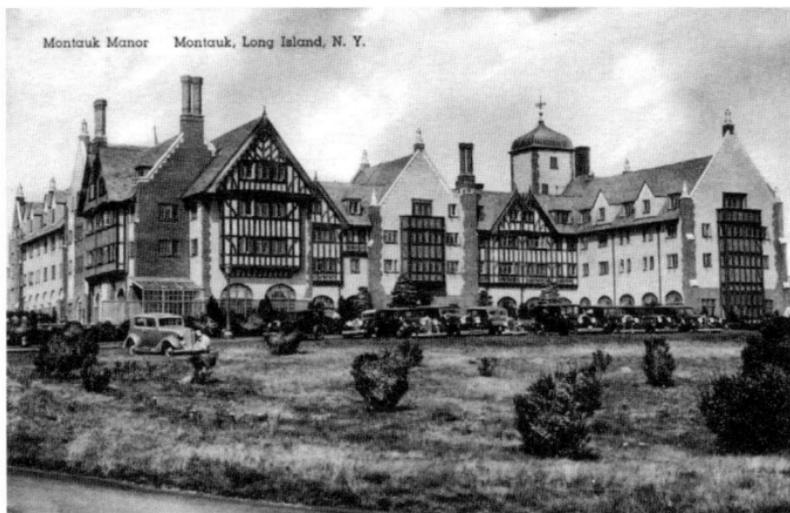

Montauk Manor Montauk, Long Island, N. Y.

The developer Carl Fisher (1874–1939) was the driving force behind the creation of the two-hundred-room Montauk Manor resort hotel. Completed in 1927, the hotel, along with Fisher's other ambitious plans for Montauk, was not as profitable as he would have liked due to the Great Depression. The hotel closed in 1964. It was recently renovated and is now a condominium hotel with 140 apartments.

PLACES AND EVENTS

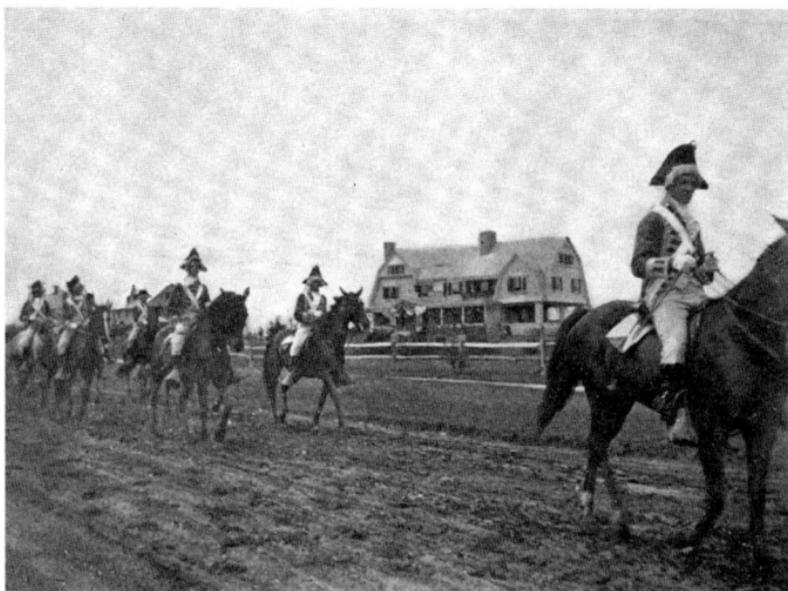

The August 1899 parade celebrating the 250th anniversary of the founding of East Hampton included a group of Continental soldiers led by B.Z. Griffing in uniforms of blue and white, with wigs. A lifeboat and crew from the Georgica lifesaving station, led by Captain Nathaniel Dominy Jr., were also in the parade celebrating the founding of East Hampton.

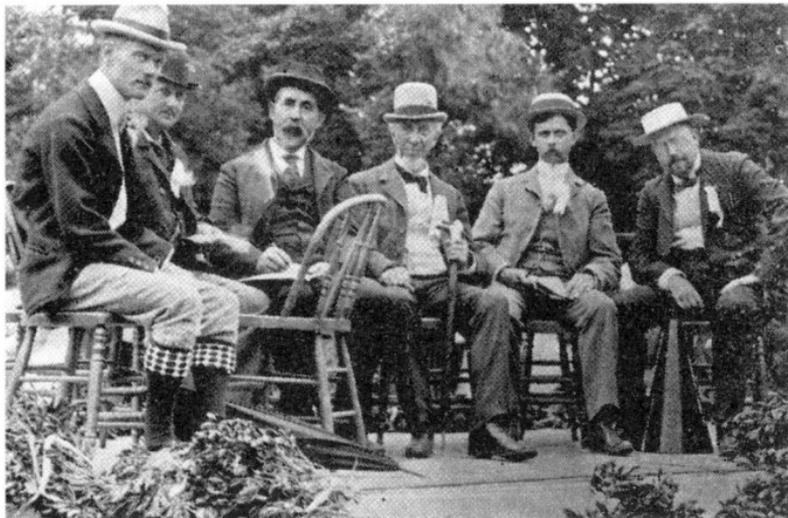

Judges of the 250th anniversary parade in East Hampton are ready to make their decisions. Prizes included sterling silver Reed and Barton items, notably a chafing dish, tankards, urns, two souvenir windmill spoons and bicycle appliances.

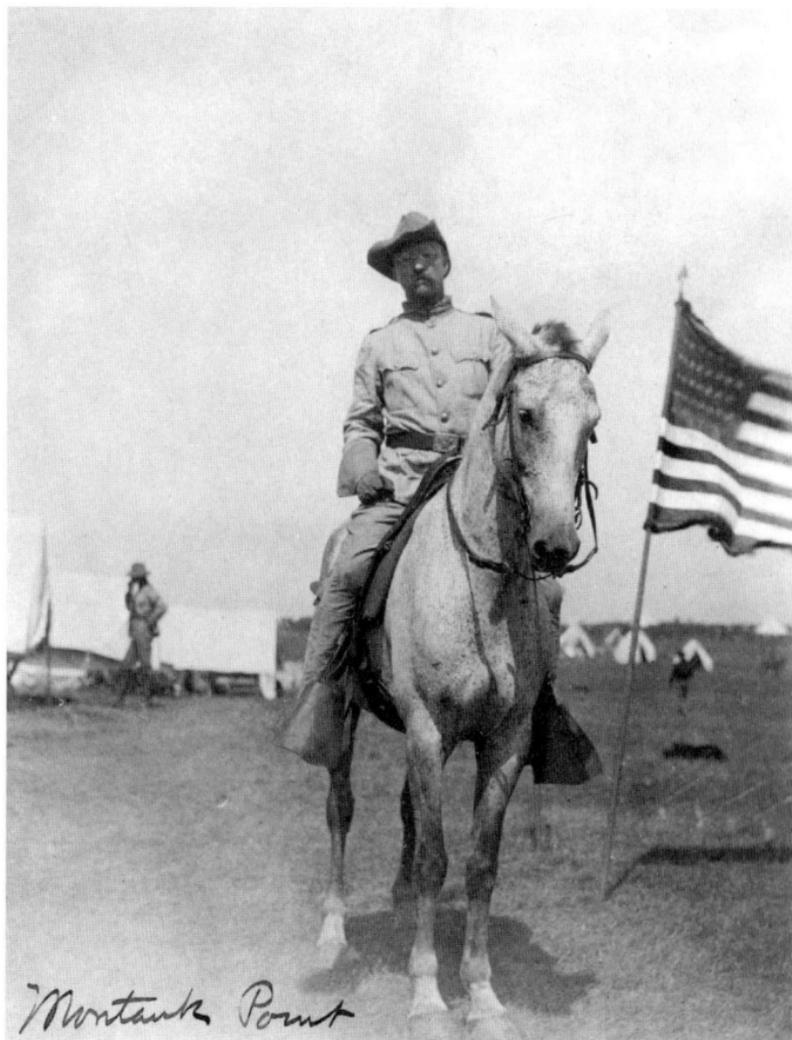

Montauk Point

Colonel Theodore Roosevelt (1858–1919) and his Rough Riders
encamped at Camp Wikoff on Montauk Point during the late summer
of 1898. In fact, twenty thousand Spanish-American War soldiers were
quarantined there while recovering from various illnesses contracted
while fighting in Cuba. The future president is seen in this image while
encamped at Montauk.

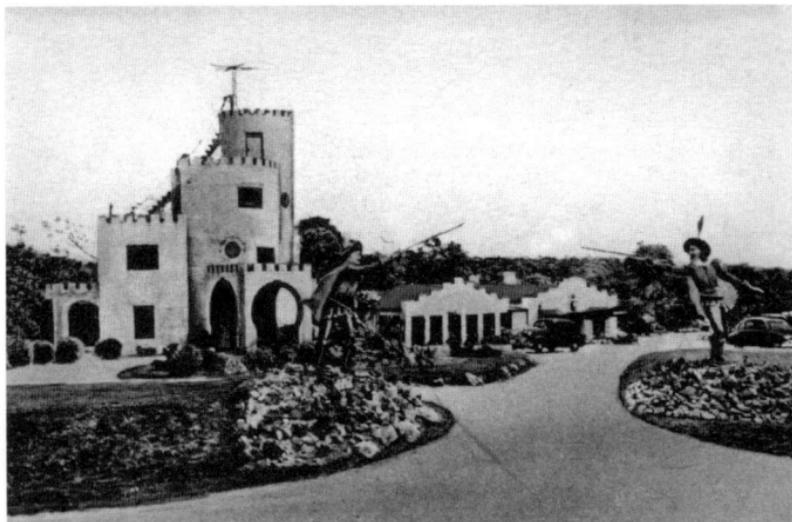

The Casa Basso Italian restaurant on Montauk Highway in
Westhampton has been in operation since 1928. This castle-like
landmark is known for the several sculptures on the property, including
the famous twelve-foot-tall fencers that greet customers. The restaurant
is shown here probably during the 1940s.

Places and Events

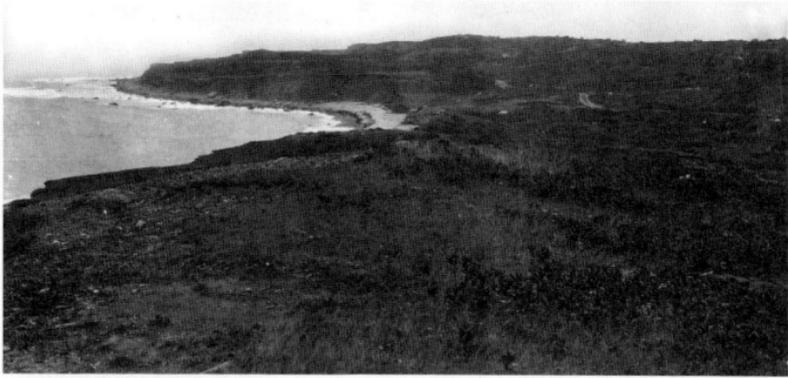

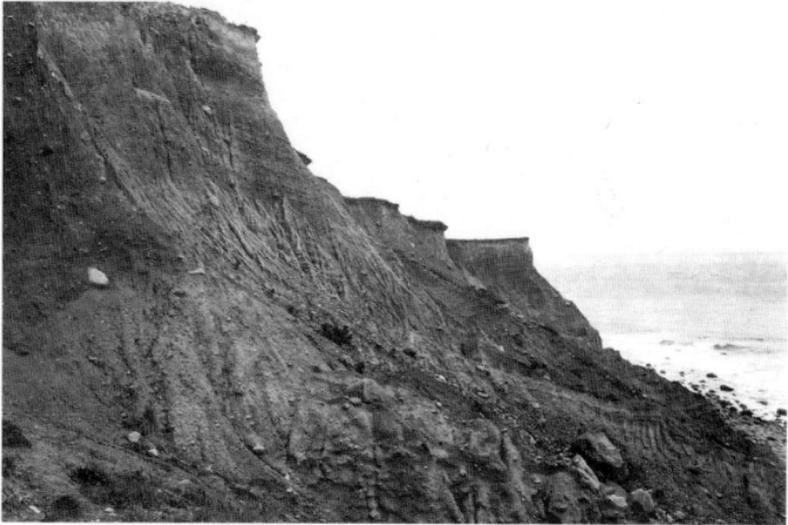

This page: Both Orient Point and Montauk Point exhibit some interesting geological characteristics, remnants left behind by the retreating glaciers during the last ice age. The top image is a view of the upper part of the bluff a half-mile southwest of the Montauk Lighthouse. It shows glacial till and bold projecting features. The bottom photo shows a bluff at the extreme end of Montauk Point, below the lighthouse, showing the Montauk glacial till. Both photographs are United States Geological Survey images that date to 1917.

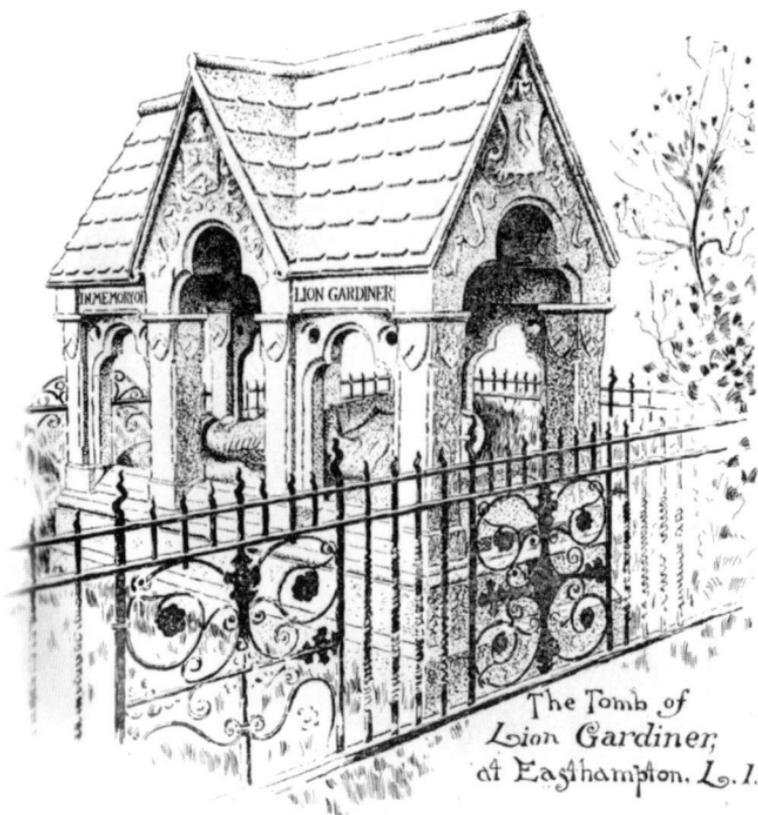

The Tomb of
Lion Gardiner,
at Easthampton. L. I.

Lion Gardiner, the first owner of Gardiners Island, died in 1663.
He had moved from Gardiners Island to East Hampton in 1653 and
was buried there. In 1886, this intricate monument was designed
by the noted architect James Renwick and built in East Hampton.
While excavating for construction of the monument, workers found
Gardiner's skeleton still intact.

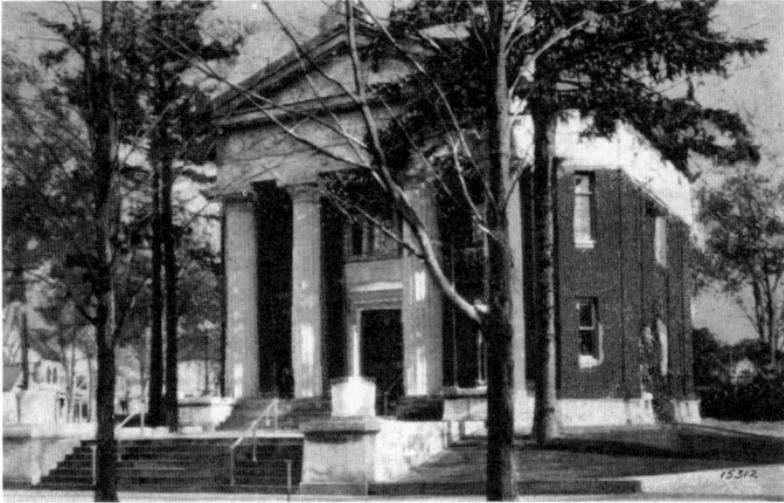

The John Jermain Memorial Library in Sag Harbor was funded by Mrs. Russell Sage and completed in 1910. It was named in honor of her grandfather. The property cost $10,000 to purchase and the building cost $70,000 to construct—a small fraction of the vast fortune her husband left her when he died in 1906. It is depicted here circa 1925.

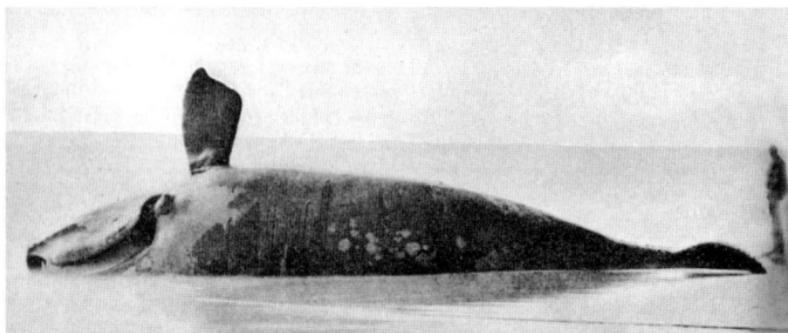

When a whale was spotted off the waters of the South Fork, horns were blown and crews of men quickly went out in boats to try to kill the creature. One whale could yield about thirty barrels of valuable whale oil. The person who raised the alarm would receive about ten gallons of oil. The rest of the oil was split among the men who were on the water at the time of the kill. This image shows a whale killed near Bridgehampton in 1882.

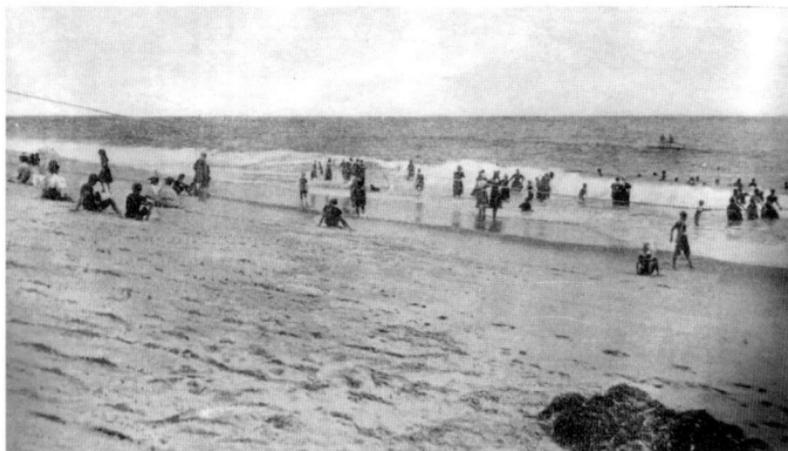

Beachgoers bathing in the surf at East Hampton, circa 1899. By this time, the community was a mix of residents whose grandparents and great-grandparents had been born there, recent year-round transplants from New York City and wealthy residents who summered there.

Places and Events

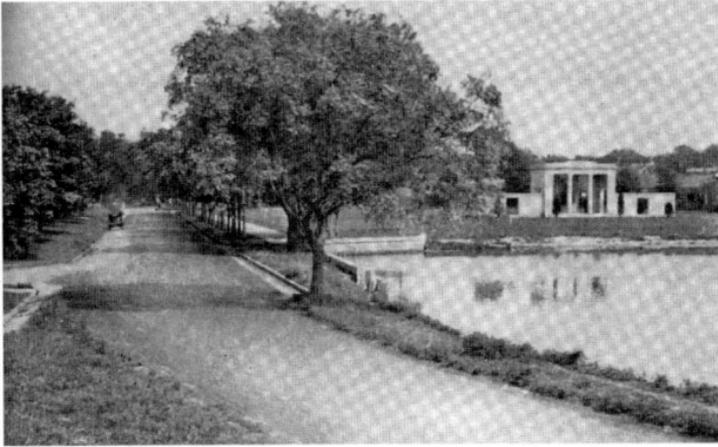

Formerly a swampy area ("Hell's Half Acre") with a saloon and a few run-down buildings, Southampton's Agawam Park was created during the early twentieth century. A World War I memorial was built featuring the names of those Southampton citizens who fought in the war. The park is adjacent to Lake Agawam. This image dates to about 1944.

The Hither Hills State Park in Montauk, first opened in 1924, was one of the earliest state parks in New York. It was attractive to visitors because it offered camping sites; ordinary visitors could enjoy the South Fork scenery without paying the exorbitant prices at local hotels and resorts. Shown here is the bathhouse at Hither Hills, circa 1940s.

Above: A peaceful drive in Flanders is depicted, circa 1908. Flanders is located along Route 24, the gateway to the heart of the South Fork, four miles from Hampton Bays and eleven miles from Southampton. Today, Flanders is most famous for the "Big Duck," a roadside attraction that was built during the 1930s.

Left: A woman standing on a Southampton beach waves to a friend in a 1945 photograph used on the back cover of a tourist brochure about Southampton. Tourism to the South Fork continued to increase as the twentieth century progressed; with faster cars of the 1940s and 1950s, the trip became even easier than it had been, and again with the expansion of the Long Island Expressway to Riverhead in 1972.

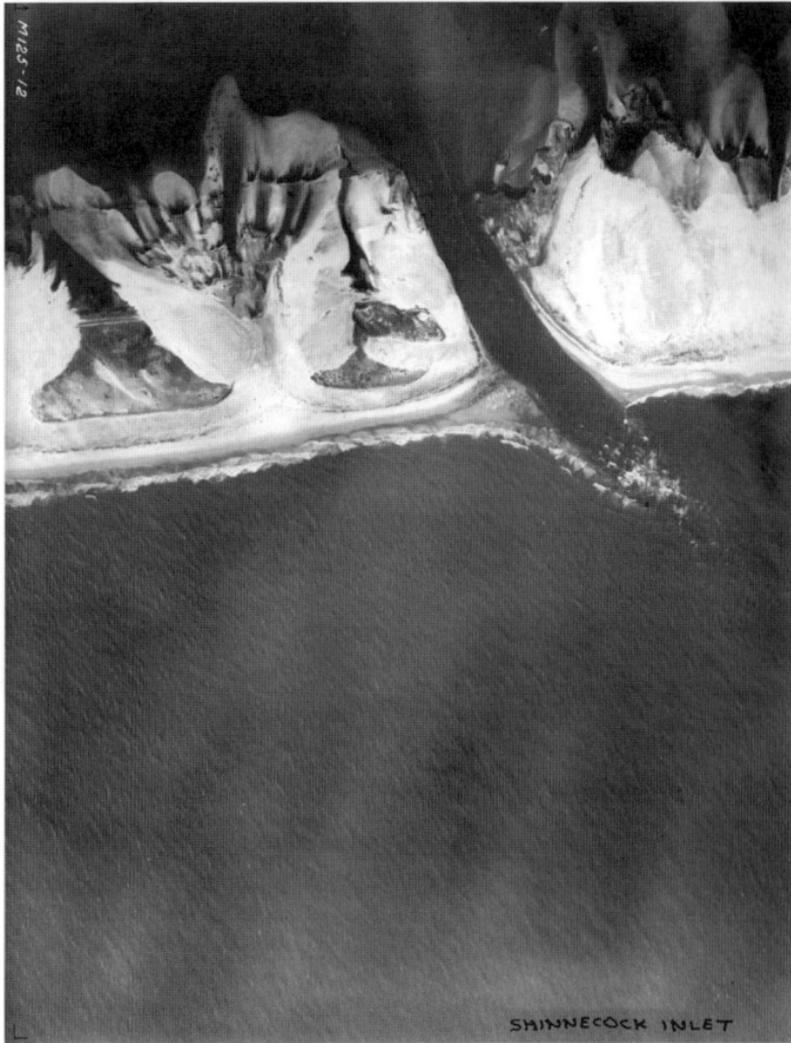

SHINNECOCK INLET

The Hurricane of 1938 surprised Long Island and New England with severe winds and storm surge. The South Fork was hard hit, and many waterfront buildings were damaged or destroyed. The hurricane also altered the East End's geography, creating the Shinnecock Inlet, as seen in this aerial photograph taken shortly after the storm.

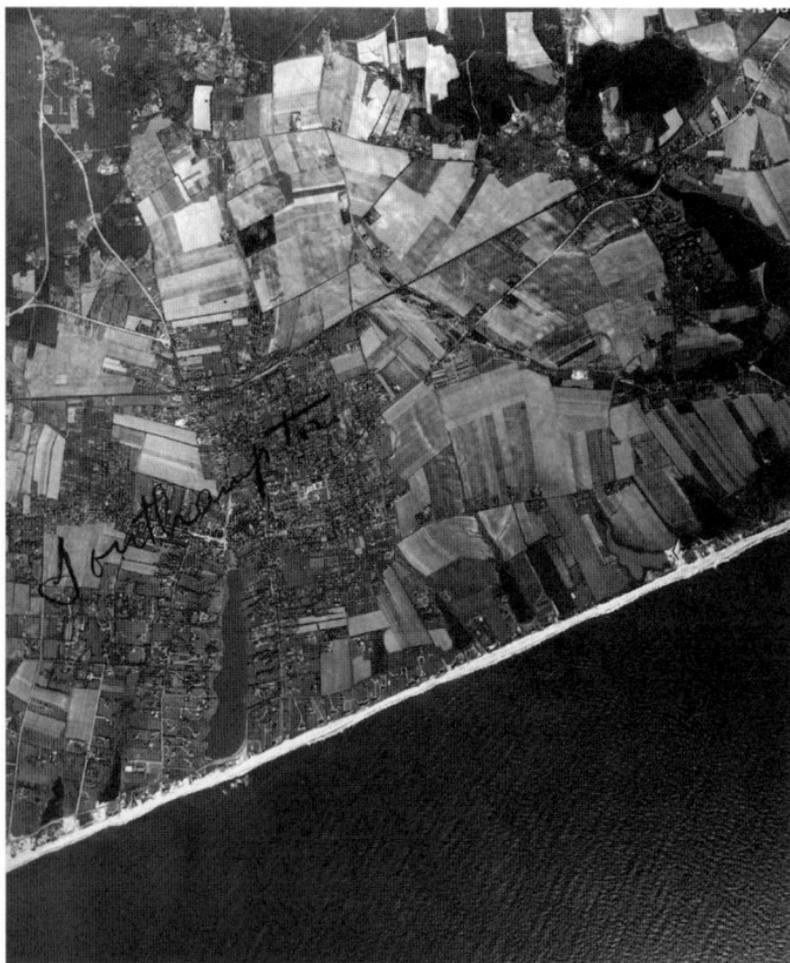

This aerial view of Southampton in 1941 shows the developed center of town but also a great deal of farmland and undeveloped property surrounding the developed areas. Nearly all of the open space shown on the 1941 view has now been developed. The body of water at the lower left is Agawam Lake.

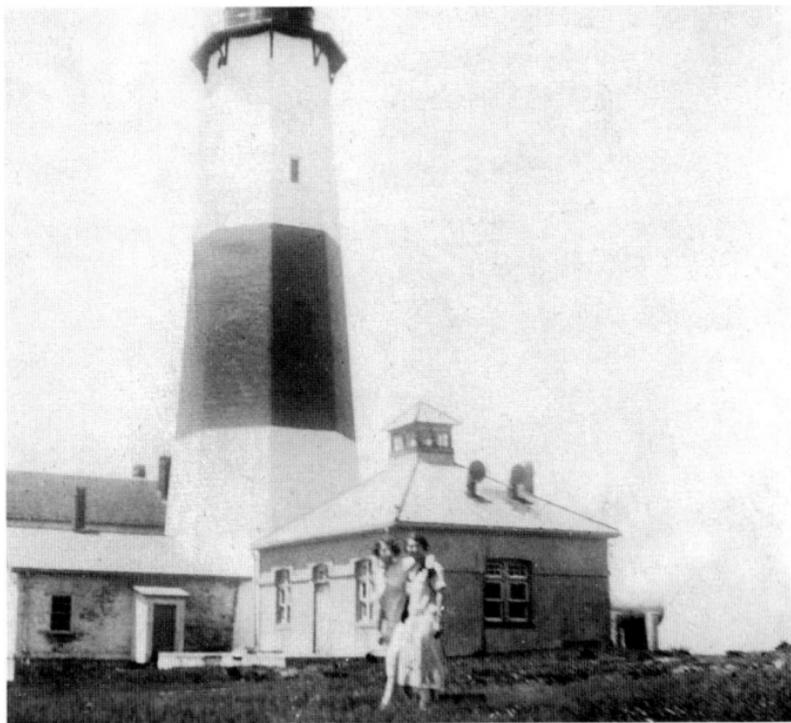

For hundreds of years, visitors have set out on hours-long journeys to Montauk Point. There, they inevitably stand upon the water's edge and contemplate the vast ocean stretching out before their eyes. A description of the scene from the 1870s is timeless in its accuracy: "Everlasting surges of the ocean are almost continually dashing with irresistible fury." Tourists visiting Montauk in 1925 snapped this photograph.

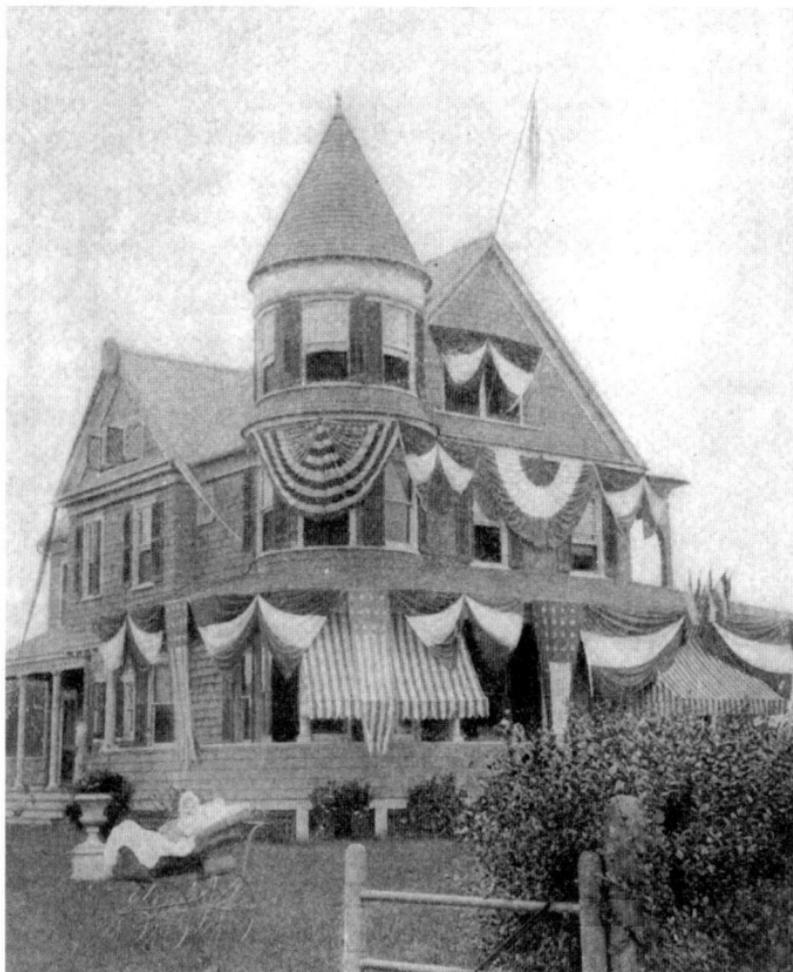

The Committee on Decorations oversaw the adornment of homes, churches and shops in celebration of the 250th anniversary of the founding of East Hampton in 1899. Homes were decorated with all manner of colorful wreaths, ribbons, bows, flags, streamers, banners and draperies. Shown is the residence of J. Edward Huntting, member of a prominent local family.

Places and Events

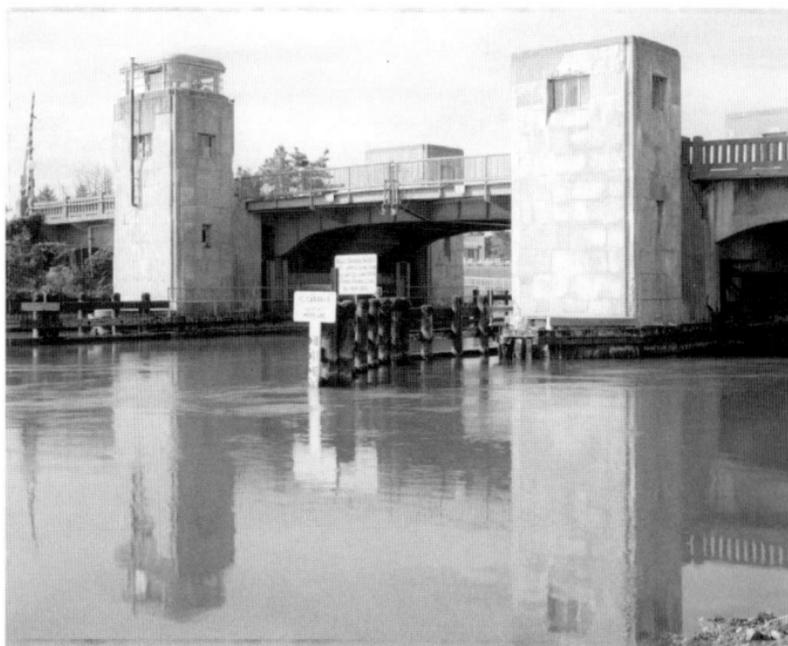

The Quantuck Canal Bridge (Beach Lane Bridge) was built in 1935. This 164-foot-long double-leaf bascule bridge spans the Quantuck Canal in Westhampton Beach, 400 feet north of Dune Road. The operator's tower features an Art Deco frieze depicting scenes from Long Island history.

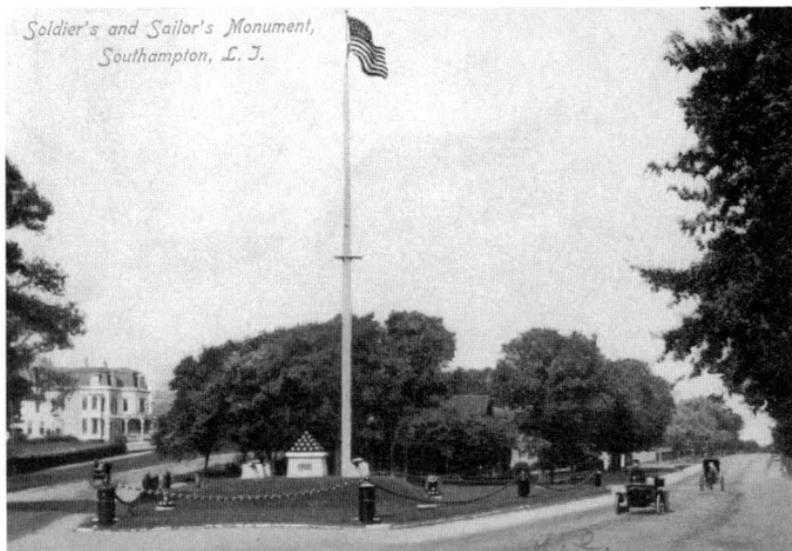

Soldier's and Sailor's Monument, Southampton, L. I.

The Soldiers and Sailors Monument was erected in Southampton in 1897 to commemorate the local participants in wars from the Revolution to the end of the nineteenth century. The monument is shown here in a view from 1908.

Places and Events

Homes for the rich were not the only ones being built on the South Fork during the early twentieth century. Shown here is an "inexpensive" cottage in Southampton. According to the 1906 magazine in which it appeared: "It has an air of picturesque freshness which is essentially appropriate summer living. The economically-arranged interior contains five rooms and bath and is suggestive of solid comfort."

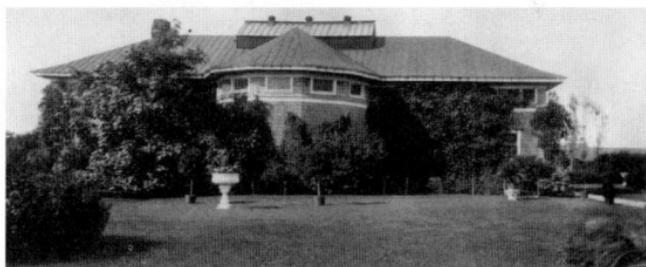

Samuel L. Parrish, who was born in 1849 in Philadelphia and arrived in 1886 in Southampton, founded the art museum that now bears his name. He founded the museum in 1898 in a building designed by Grosvenor Atterbury. Additions were made in 1902 and 1913, also designed by Atterbury. The museum contains a replica of the Bayeux Tapestry. Parrish was elected president of the village of Southampton in 1901, about the time that this photograph of the museum was taken.

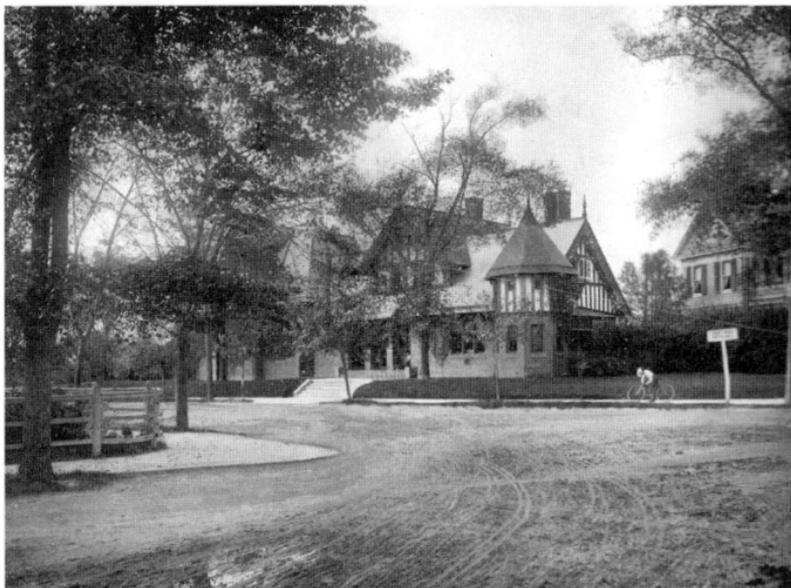

The Rogers Memorial Library in Southampton was founded using a $10,000 bequest from Harriet Jones Rogers, who died in 1892. The attractive building was dedicated in 1895 and opened in 1896. The library currently serves a population of twelve thousand.

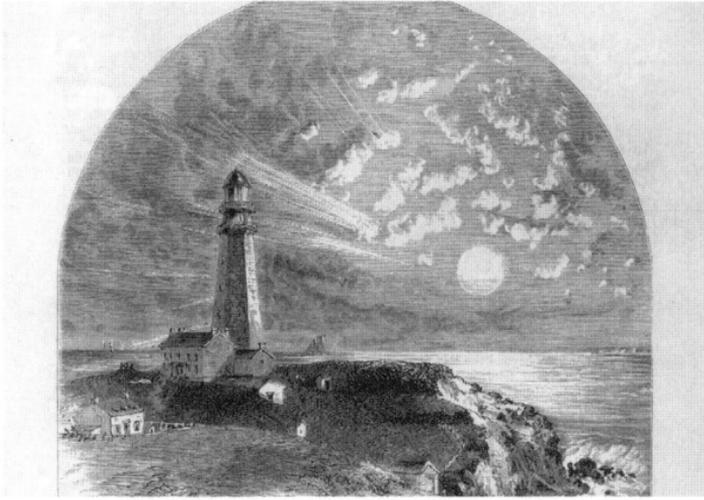

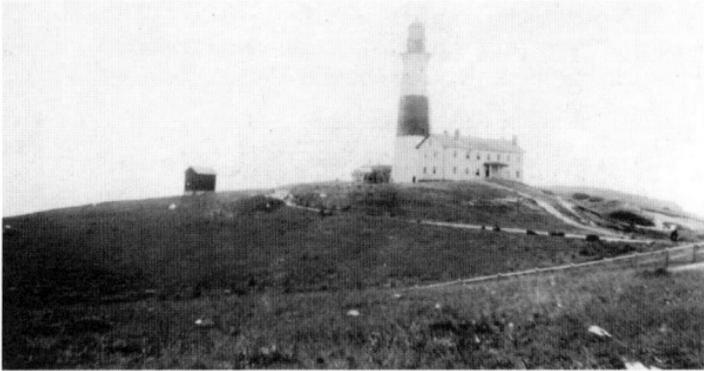

Congress authorized the Montauk Lighthouse in 1792, while George Washington was president, and it was built in 1796 on Turtle Hill (known by the Indians as Wamponamon). It is the fourth oldest active lighthouse in the United States. Though there are numerous lighthouses along the East and West Coasts, the Montauk Light has always held a special place in the popular imagination because of its location at the tip of Long Island. The lighthouse is seen here on the cover of an issue of *Harper's Weekly* in 1871 and again in a 1925 photograph.

Visitors from New York City, Nassau County and western Suffolk County have been going to see the eighty-five-foot-high Montauk Lighthouse for well over one hundred years. This photograph of Montauk Point was snapped by tourists from Nassau County in July 1925. In those days, without the Long Island Expressway or Northern State Parkway to get one partway there, the trip took considerably longer than it does today.

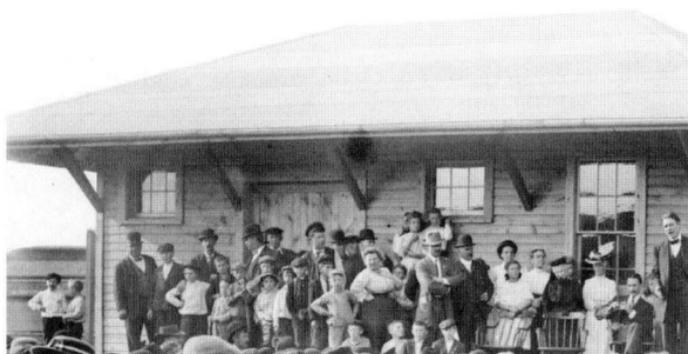

This image shows a large crowd gathered at the Sag Harbor train station in the fall of 1908 to hear a campaign speech by Lieutenant Governor Lewis Stuyvesant Chanler, who was running (unsuccessfully) for governor.

Places and Events

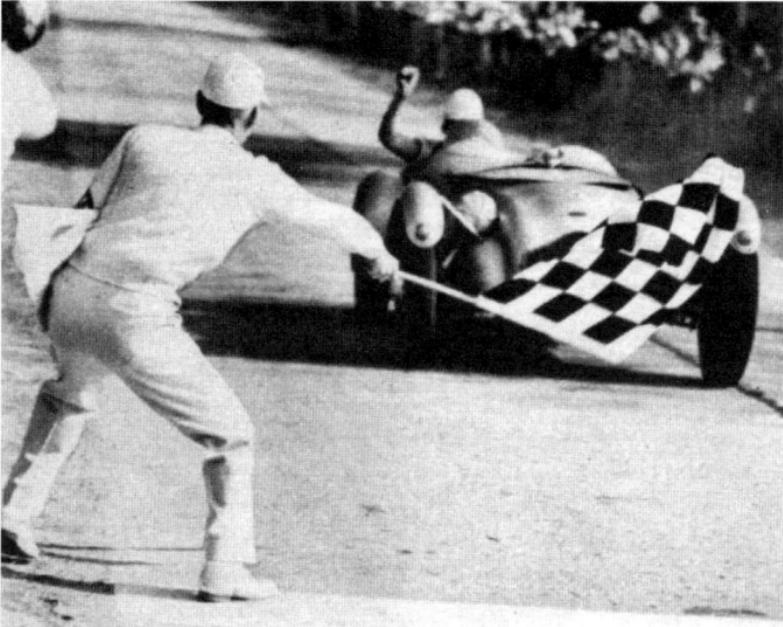

Auto races were held on Bridgehampton roads during the late 1940s and early 1950s. After pedestrians were killed in 1953, the road races were halted and a racetrack was built. The track hosted numerous races during its heyday in the 1950s and 1960s. It was demolished to make way for a golf course. This image is from an advertisement for the May 1952 Sports Car Invitational races.

Visit us at
www.historypress.net